Dedicated to my wife, Margot, who shares my
passions for the wonders of the world.

Ich liebe dich.

Foreword

Cannabis, marijuana, grass, dope, herb, reefer, weed, mary jane, pot, and hemp are all names that refer to a plant with a long and complicated history. Cannabis was first used for recreation in ancient Greece when by accident plants were burned. History recorded the Scythians sharing that "once thrown on red-hot stones, the plant immediately gives out such a vapor as no Grecian vapor bath can exceed."

—Herodotus (translated by George Rawlinson) (1994–2009). "The History of Herodotus." The Internet Classics Archive. Daniel C. Stevenson

Marijuana continues to be a popular recreational drug worldwide. It is estimated that more than 100 million Americans alone have smoked the dried female buds of this plant. It is popular because of the various states of relaxation or euphoria produced when the plant is smoked. Pot smokers also describe feeling a heightened sense of creativity and philosophical thinking when stoned.

Medical use of the plant, which contains THC or tetrahydrocannabinol, is also increasing and is useful in managing nausea resulting from chemotherapy treatments. Cannabis is actively being researched for its therapeutic value when used to treat epilepsy, chronic pain, and muscle spasms. One of the plant's species, hemp, is important to industrial use because of its special, long fibers. Hemp fibers are used in paper, cordage, textiles, and clothing. Fabrics with hemp fibers last longer than those made with cotton.

And now, because of this book, cannabis's anatomical features can be enjoyed for their microscopic beauty and structure. The pictures provide a unique viewing experience. Originally created as scientific photographs, they span applications in both scientific fields and the visual arts.

If you are reading this essay, I assume you have interests in photography, science, art, and

the process of discovery. Each handsomely reproduced image is special for different reasons. The photos transcend science and allow viewers to peek into the invisible world in new ways.

Contemporary photography and imaging are playing new roles in making science images more accessible to the masses. Some of the images in this book are examples of leading-edge imaging methods that include computational photography. Computational pictures are the result of numerous individual photographs assembled into one image. One important outcome for each of the photographs is that beyond their technical excellence, they are engaging on an aesthetic level that allows them to be enjoyed for their innate beauty and structure that is not typically visible without magnification.

For many obvious and not so obvious reasons, there are often challenges in making pictures like these. This includes events that are transitory, samples that require photographing with special equipment, or uncooperative subjects entirely. These challenges make the creation of the highest-quality pictures difficult to achieve for even the very best scientist photographers. That is what makes the photographs in this book so special. Achieving the results demonstrated across this entire collection of photographs requires great precision, attention to detail, planning, knowledge, skills, and most important—the desire to do so.

The photographs in this book function both as science and art. I think this outcome is rooted in the simple fact that they are scientifically accurate and share scientific facts in ways that allow viewers to add their own interpretation about what they believe they are seeing. This perceptual component of seeing can be exciting and lead to intrigue when looking at the unknown. I am sure readers will enjoy the experience of seeing marijuana photographed in a new way.

I hope you enjoy this marvelous collection of photographs produced by a wonderful and talented colleague, Ted Kinsman. Expect to be surprised.

—Professor Michael Peres, Rochester Institute of Technology

Introduction

Recent changes in the perception of cannabis have shifted the plant from the world of crime to the forefront of science. No longer left to the amateur breeder, the plant is now the focus of serious scientists armed with the latest in DNA sequencing, plant cell propagation, and carbon dioxide chemical extraction equipment. The list of chemicals produced by the cannabis continues to grow as more researchers explore this plant's potential. Tetrahydrocannabinol, or THC, is the principal psychoactive constituent of the cannabis plant and is one of dozens of chemicals now called cannabinoids. As the cannabis plant moves toward a commercial industry, we can expect to see many changes. New plant breeds or cultivars are created to produce faster harvests, higher yields, and even higher concentrations of THC. Cultivars will be standardized, DNA sequenced, and optimized for different cannabinoids besides the standard THC. The role of science will continue to affect the industry's development.

The cannabis plant has many structures that make it unique. It has developed fortifications, both physical and chemical, against attack by grazing animals and insects. The plant production of defensive chemicals is classified as secondary metabolites. Secondary metabolites aid a plant in important functions such as protection and competition, but are not necessary for survival. Examples like caffeine, cocaine, and aspirin (originally from the bark of the willow tree) fall into this category. The chemical defenses in the cannabis plant are concentrated in cells, called glandular trichomes, that extend from the leaf surface. The female plant concentrates these cells on new leaves and at the flower bud. These locations are critical to the plant's survival and reproduction. These chemicals are not only toxic to insects but are sticky, to help entrap and incapacitate them. The effect of these chemicals

on humans is what has driven the selective breeding to higher and higher levels of THC. The plant's physical defenses are numerous, mostly taking the form of thorn-like structures called trichomes. These trichomes (different than the glandular type mentioned above) cover the plant in different densities depending on its location and age.

The book makes no distinction between the different cultivars of cannabis, mostly due to the confusion surrounding their identification. All the different cultivars, with their colorful names, are the same species (*Cannabis sativa*). I encourage the reader to think of the different strains as similar to different dog breeds. All dogs are the same species (*Canis familiaris*), but great Danes have different characteristics than a chihuahua. In the future, DNA research will help identify the plant origin and guide breeding efforts to maximize desired cannabinoids.

Cannabis: Marijuana Under the Microscope contains a number of scanning electron microscope images that are inherently black-and-white pictures. Color plays an important role in our lives, as it does in art. The images were false-colorized in a labor-intensive process using Photoshop. Color was applied in an artistic manner and is often used to highlight a structure that is normally clear or a uniform green color. The colors are explained in the image descriptions. The use of color was designed to open up the imaginary, and to make it accessible to a larger viewing audience.

The sample collection and imaging process is very complicated for cannabis, as it is for most plant material placed in the vacuum of a scanning electron microscope (SEM). As the image collection progressed, it soon became apparent that dried samples of cannabis were too deformed to use. The challenge was to obtain fresh samples to be able to image perfect surface structures on the plants. To achieve these images, the microscope had to be modified to handle fresh specimens that were quickly frozen in liquid nitrogen. Late

nights were spent in the machine shop making special holders that would snap a stem under the surface of liquid nitrogen so it did not collect water vapor from the environment before it could be imaged in the SEM. These cryogenic stages allowed the plant samples to be imaged in the SEM while frozen. In turn, this allowed large glandular trichomes to be imaged before they deflated like a discarded party balloon. Countless hours were spent perfecting the technique to keep the beam of electrons from damaging the surface features before they could be imaged. Live samples were obtained from the best strains and grown to maturity to be able to image the fine structures time and time again. This process tested dozens and dozens of high-quality plants and seeds to find the ideal specimens.

The visible light macro images were photographed with a macro lens or a light microscope. To achieve the best images with a large depth of field, a number of individual images are taken with different levels of focus. The resulting stacks of images are combined in specialized software to create one image with exceptional depth. This focus stacking process was key to creating some of the images.

The image descriptions are kept as simple and straightforward as possible. Complex plant part names have been left out and substituted with an explanation of what the structure does. For instance, descriptions like capitate stalked glandular trichomes have been shortened to "stalked glandular trichomes." The complex classifications of trichomes that are documented in many research papers is simplified to be physical descriptions of the structures. I hope plant anatomy scientists will forgive me for taking this liberty. In my research, it is apparent that there is a tremendous amount of confusion involving the use of the male and female plant parts. The goal is that these images will establish a bridge between the world of science and the world of art to allow the viewer a deeper understanding of the workings of a cannabis plant.

I hope the reader will enjoy these images as much as I did while photographing them. My goal is to inspire respect for cannabis, as well as the beauty of all plants in the natural world.

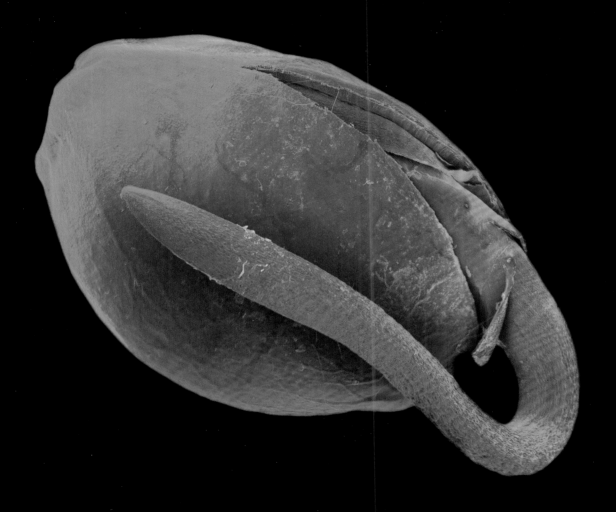

Fig. 1. A scanning electron microscope (SEM) image of a cannabis seed that had germinated for only twenty-four hours, shown in false color. Print magnification is x25.

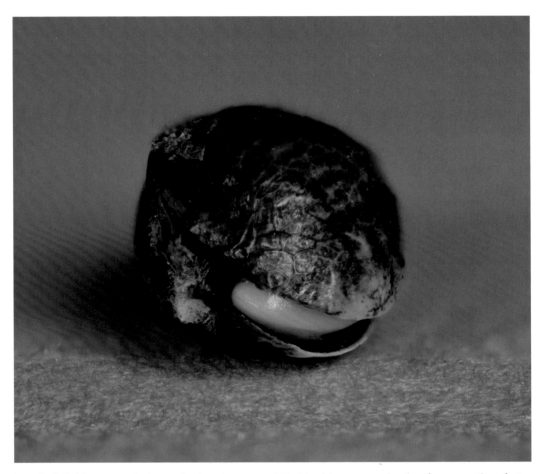

Fig. 2. A light macro photograph showing a seed that had been germinating for more than forty-eight hours. There is a large variation in the time needed for a cannabis seed to germinate, ranging from one to eight days.

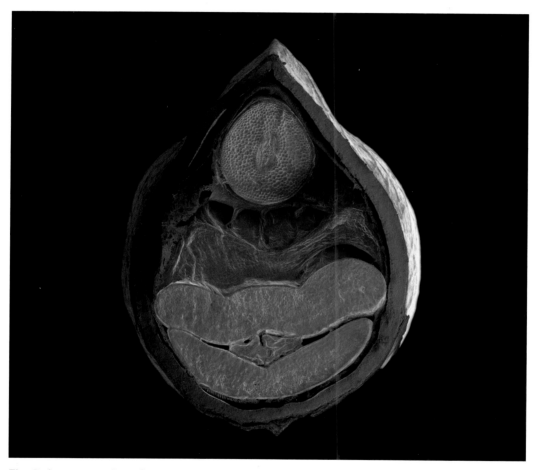

Fig. 3. A cross section of a cannabis seed shown in false color in the SEM. The circle at the top will grow to be the tap root or main root. The two green areas at the bottom are the stored leaves that the plant will unfold after reaching the surface to get the plant growing. The two green areas inside this embryo are the embryonic first leaves. This structure is called the cotyledon.

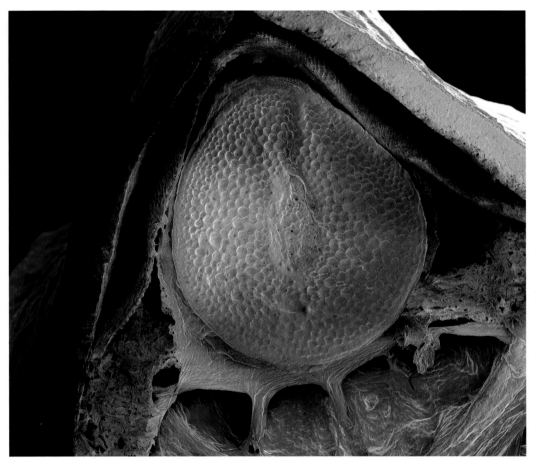

Fig. 4. A close-up SEM image of the embryo inside the seed. The circular structure will become the tap root upon germination. The seed can detect the direction of gravity and sends the tap root down. Scientists are still studying the exact chemical reactions that cause this behavior.

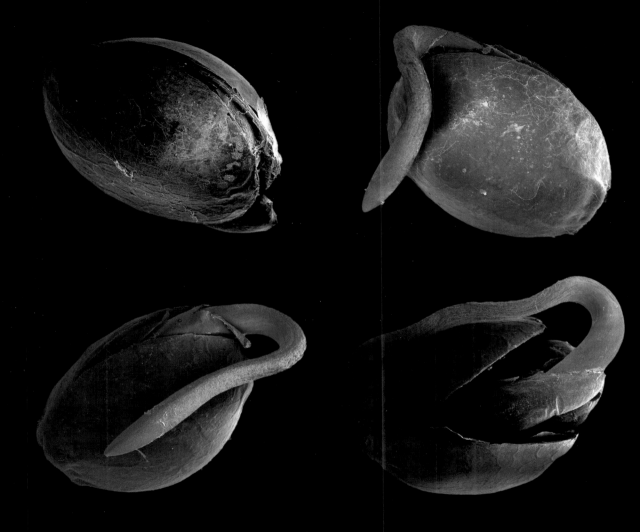

Fig. 5. Four seeds sprouting after two days of germination. This is a hybridized seed and will germinate a little slower than other varieties.

Fig. 6. The seed surface is a grooved structure that absorbs water and repels bacterial growth. The seed is a storehouse of proteins. Once water and the correct temperature are experienced, not only does germination start but the seed becomes a perfect environment for bacteria and paramecium. Print magnification is x900.

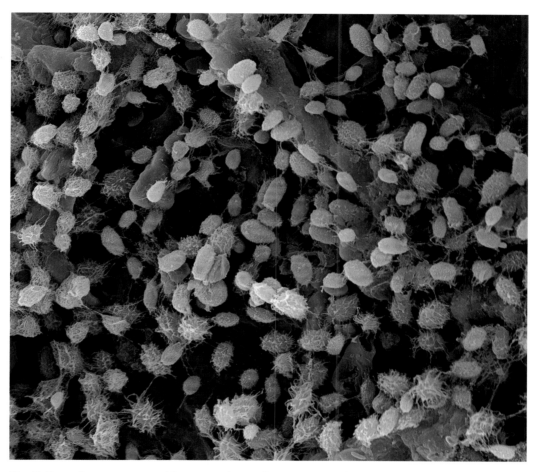

Fig. 7. Bacteria, protozoa, and fungus make up the ecosystem that lives on the moist surface of a germinating cannabis seed. It is unknown if these organisms help or hinder the plant. It's possible that they are just looking for a nice piece of real estate to live on. Food, a nice temperature, and lots of water are attractive to just about every microorganism on the plant. Print magnification is x2600.

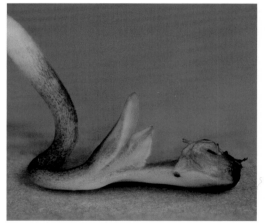
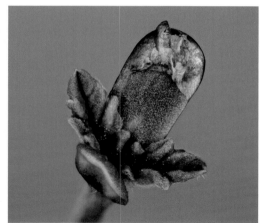

Opposite page, left to right:

Fig. 8. A cannabis seed after three days of incubation (at 21°C) on a damp paper towel and kept in the dark. This seed is ready to be transferred to soil or a hydroponic system.

Fig. 9. This is a five-day-old plant just emerging from damp rockwool. Rockwool is a fibrous material made by spinning molten rock in a machine similar to a cotton candy machine. The rockwool turns out to be a perfect medium to grow plants, as it allows both hydroponic chemicals and air to reach the roots. The plant is kept on damp rockwool for the first week before being transported to a hydroponic system.

Fig. 10. Note the concentration of hair-like trichome structures, where the THC is concentrated, on the new leaves of this young sprout. The fresh leaves are a target for insects, so the plant increases the concentration of toxins to detour attack.

Fig. 11. First leaves from the sprout, nine days after germination. The leaf surface is loaded with toxins (THC) to repel predators. The two largest leaves are the cotyledon, and a fragment of the tissue that protects the embryo inside the seed is visible at the top.

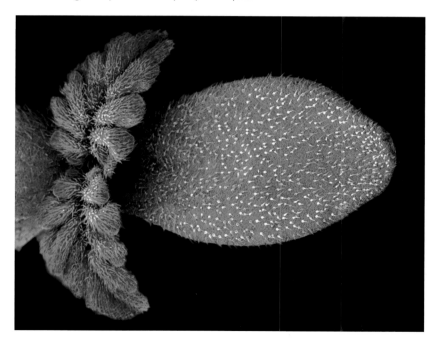

Fig. 12. Another view of the first set of leaves a seedling produces. The large, flat structure behind them is the cotyledon.

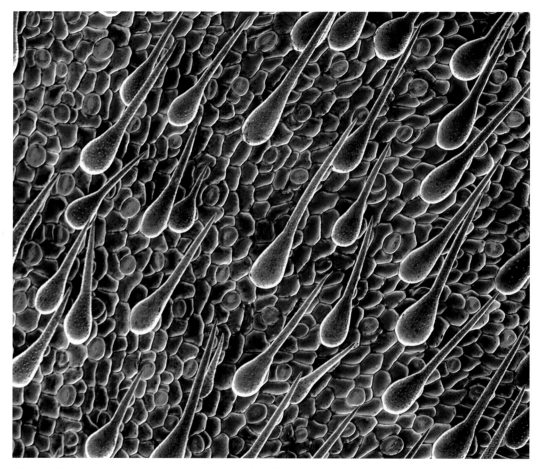

Fig. 13. The surface of the cotyledon—the scientific name for the first two leaves the plant makes. These two leaves are actually folded up inside the seed, so this structure is often called the seed leaves. It is important that the seedling gets these leaves unfolded and oriented correctly and quickly to start photosynthesis. Print magnification is x200.

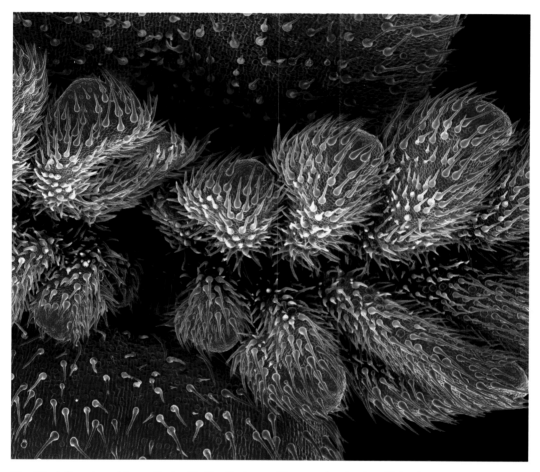

Fig. 14. A five-day-old seedling with the first set of leaves developing. This plant was supplied by a researcher developing a fast-growing cultivar for the pulp and fiber industry. The plant lacks most of the typical cannabinoid chemicals associated with medical marijuana. It funnels energy into growing and fiber production rather than cannabinoid production.

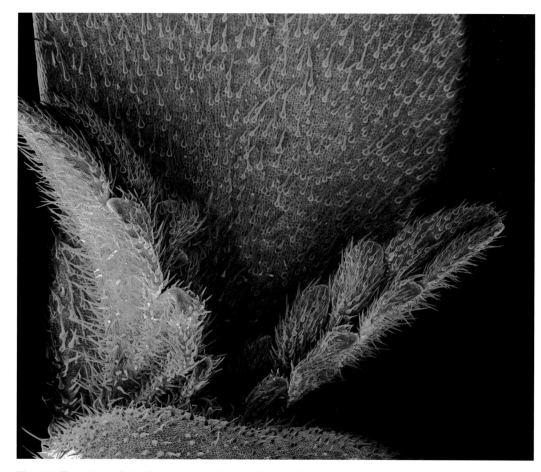

Fig. 15. The view of the first two true leaves formed by a cannabis seedling.

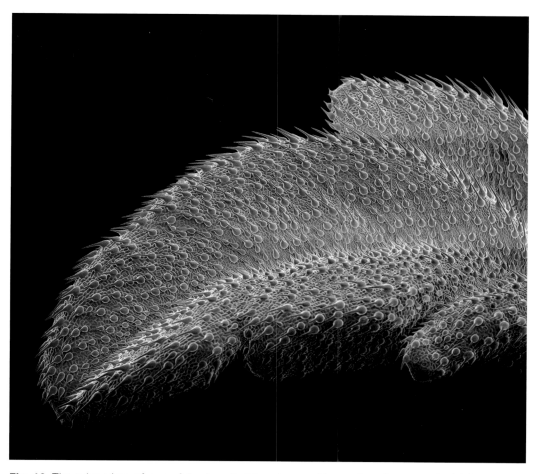

Fig. 16. The edge view of one of the two first true leaves. The surface is covered with low, thorn-like structures. These trichomes are responsible for the sandpaper feel when the leaf is mature.

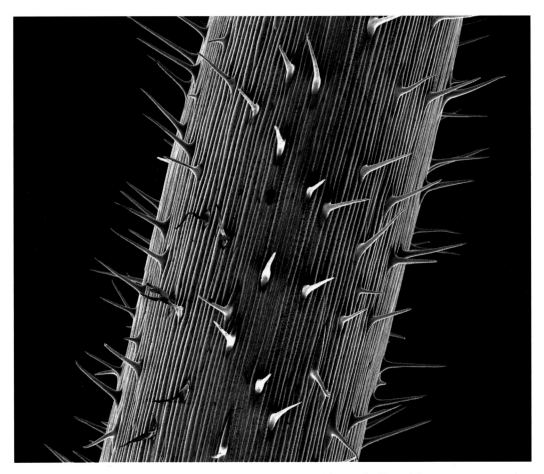

Fig. 17. The stem of a five-day-old seedling is covered with needle-like trichome structures that point toward the ground. This keeps insects from climbing the stem and eating the tender leaves. Most needle trichomes point down from the center of the plant.

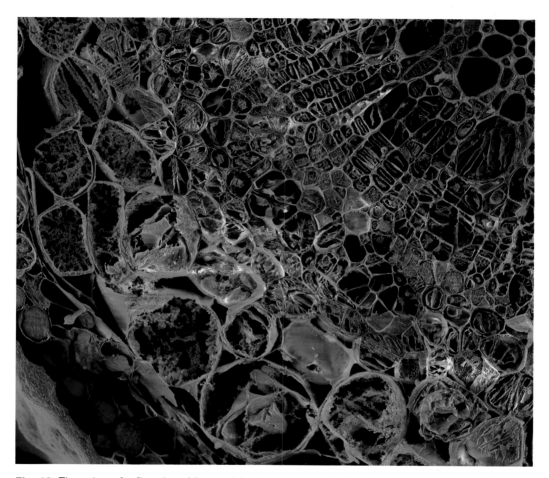

Fig. 18. The edge of a five-day-old cannabis stem, surrounded by the skin or epidermis. The next layer is comprised of strong, fiber-producing cells that hold the plant upright. The internal cell structure was captured by flash-freezing the specimen in liquid nitrogen before it was imaged in the scanning electron microscope.

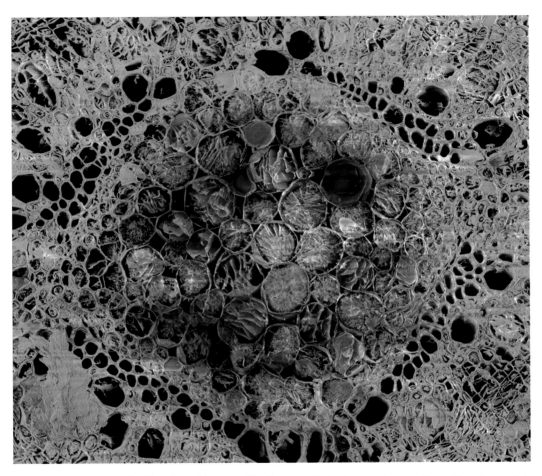

Fig. 19. The center of a five-day-old stem. The large cells in the center are the pith cells, which store nutrients. The tubes that surround the central core transport nutrients and water. This image was taken with a cryogenic stage that snapped a frozen stem in liquid nitrogen at -196 degrees Celsius, or -321 degrees Fahrenheit. This is what makes plant scanning electron microscope work so difficult. The distance across the image is 1.5 mm.

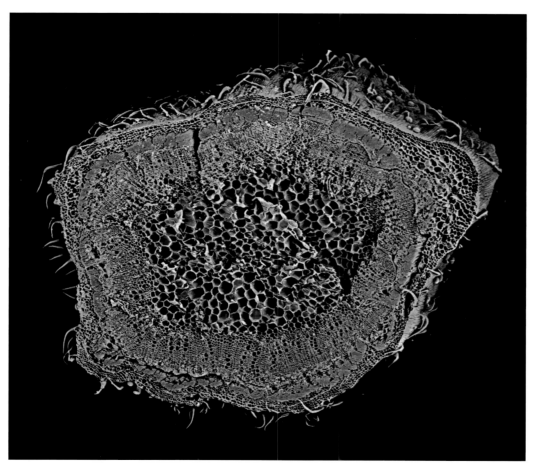

Fig. 20. A cross section of a young stem. The image is 6 mm wide. The different layers of the stem have been given different colors. A section of thick-walled fiber cells lay several layers below the skin. These fibers are a source of clothing or paper.

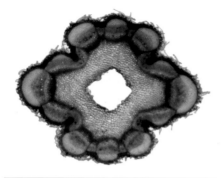

Fig. 21. A cross section of a mature plant, taken about 5 cm from the top of a mature plant, shows the central cavity—a hollow space in the middle of the stem. The stem is surrounded by structures that will develop into leaves and branches. Diameter of the stem in this optical image is 4 mm.

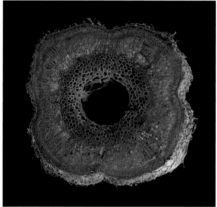

Fig. 22. SEM image of the stem in the middle of a mature plant. The central cavity is well developed and surrounded by pith cells, which store nutrients.

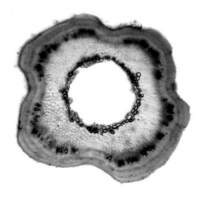

Fig. 23. Optical light microscope image of a mature plant in cross section. The stem is 8 mm in diameter and the true color shows the distribution of green chlorophyll. The hollow central cavity is ringed with dried-out pith cells— soft, spongy cells that store and transport nutrients. The stem is surrounded by the strong, green fibers that the cannabis plant is known for. Most of the stem is hollow.

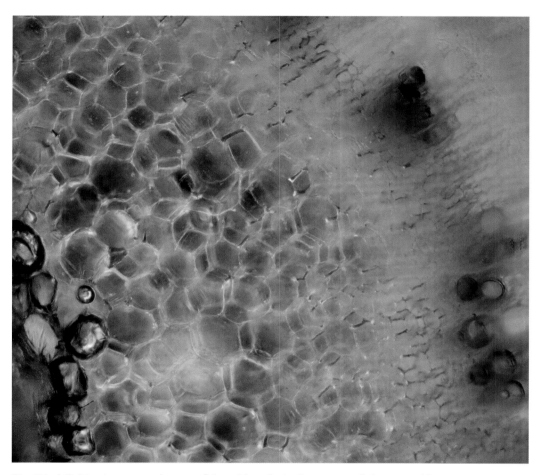

Fig. 24. A light microscope image of the pith cells in the center of the cannabis stem.

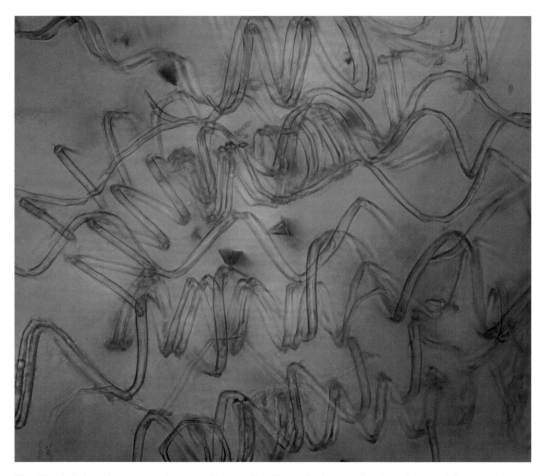

Fig. 25. A light microscope image of the coil cells, called spiral lignin, which hold open the cell walls that transport water and nutrients throughout the plant. The spiral cells are similar to the structure of a vacuum cleaner hose that helps the tube wall hold its circular shape even when stepped on. Print magnification is x1045.

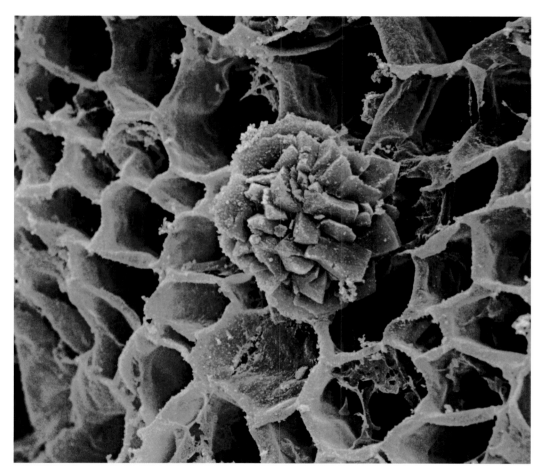

Fig. 26. A false color SEM image of a calcium oxalate crystal in the stem of a mature cannabis plant. Calcium oxalate crystals in plants are called raphides. Humans have similar calcium crystals that can appear as kidney stones. These crystals help remove calcium build-up in the tissues and repel grazing animals. They're most commonly found on the stem, but may also appear on other plant parts. Print magnification is x2500.

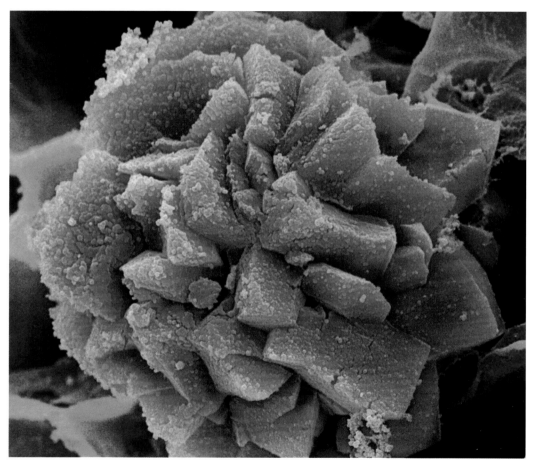

Fig. 27. A false color SEM image of a calcium oxalate crystal. Even a small dose of calcium oxalate is enough to cause intense sensations of burning in the mouth and throat. Commonly found in popular houseplants such as dumbcane (*Dieffenbachia* species), these crystals are a non-desirable ingredient in medicinal cannabis. Print magnification is x7400.

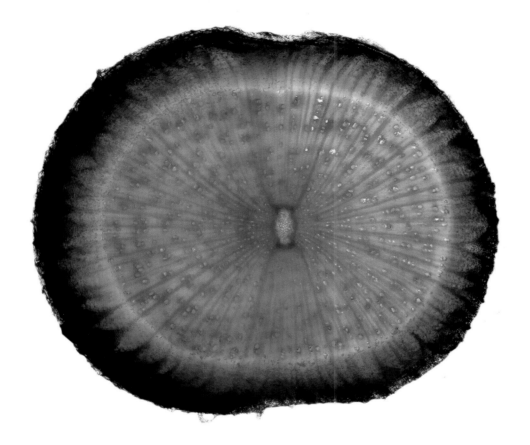

Fig. 28. A light microscope image of a cross section collected near the soil level. The stem is making the transition to root. There is no central cavity at this location and the pith cells are limited to the small area at the center of the stem.

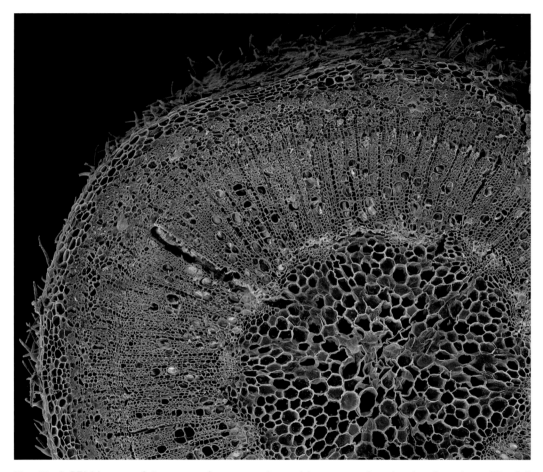

Fig. 29. A SEM image of the stem of a young plant with no central cavity developed yet. The full stem is 4 mm in diameter.

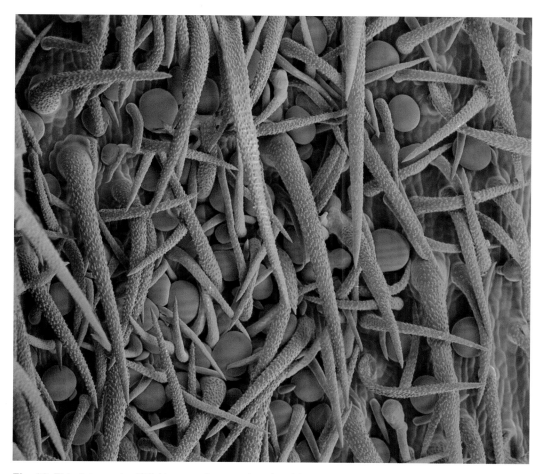

Fig. 30. This false color SEM image shows what the skin on the stem of a five-week-old plant looks like. The hair-like trichomes form a matt of thorns that protect the center of the stem from insect attack. To assist with the defense, there is a scattered layer of surface glandular trichomes that hold the cannabinoid chemicals. Print magnification is x150.

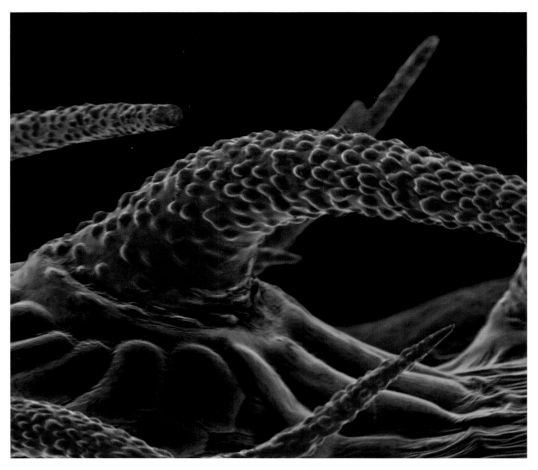

Fig. 31. A typical non-glandular trichome on the skin of the stem. This variety has the knobby calcium deposits. These structures act like barbed wire to protect the plant from insects. Print magnification is x500.

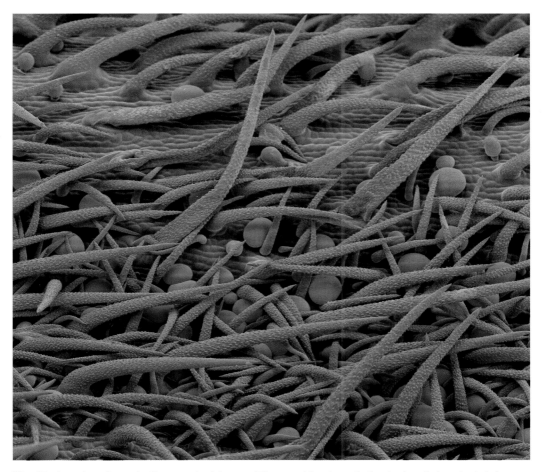

Fig. 32. An edge view of a five-week-old stem. The combination of physical and chemical defenses must work quite well, as these structures can also be found on a large number of plants including the common tomato plant. Print magnification is x125.

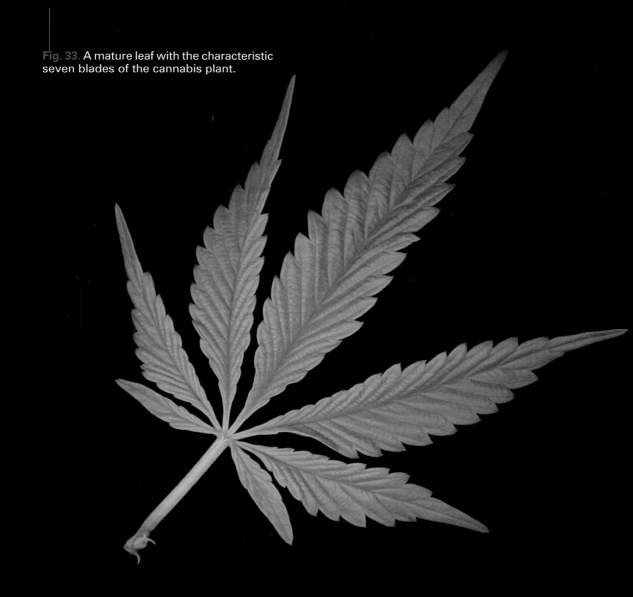

Fig. 33. A mature leaf with the characteristic seven blades of the cannabis plant.

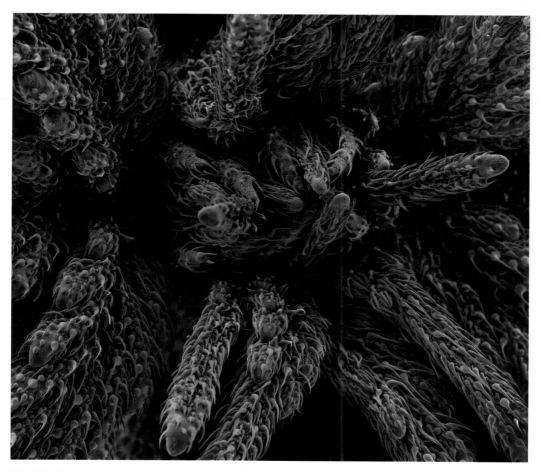

Fig. 34. The top of a two-week-old plant shows the formation of new leaves. Print magnification is x25.

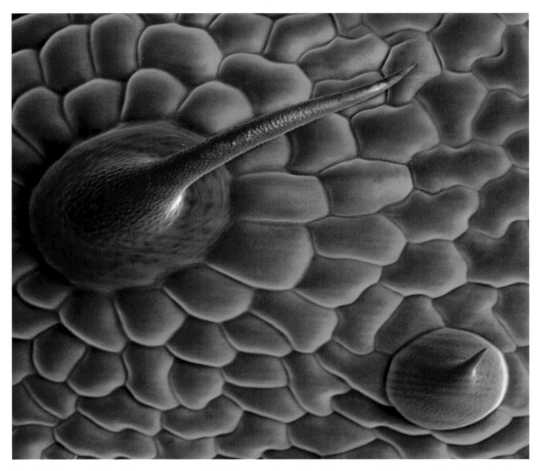

Fig. 35. Two of the different types of trichomes found on the cannabis leaves. The tall structure is the needle-like trichome, while the bottom right structure is the low spike variety. The tall structures deter larger insects while the low variety repels even smaller insects. If you rub your hand across a cannabis leaf it will feel rough like sandpaper. It is these structures that are responsible for the texture of the leaf. Print magnification is x200.

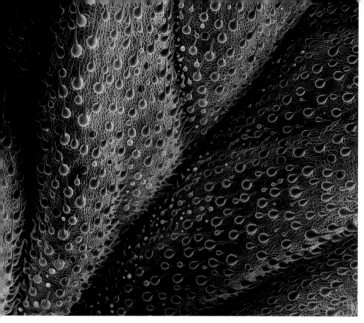

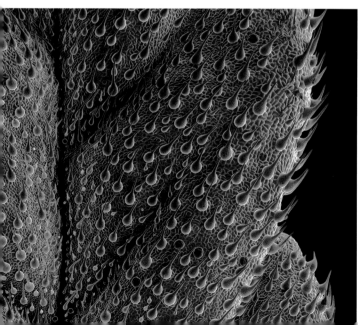

Fig. 36. and Fig. 37. Two examples of the first true leaves on a cannabis seedling. The short thorn trichomes are the most common form of protection on these leaves. As the plant matures the distribution of trichomes changes. Trichomes also change size as the plants grow.

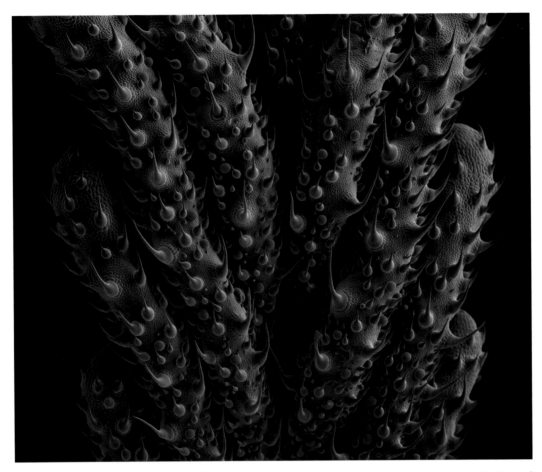

Fig. 38. A new 4-mm-wide leaf collected from a two-week-old plant shows the redistribution of trichomes. The short thorns here will grow as the leaf grows and give it a sandpaper texture.

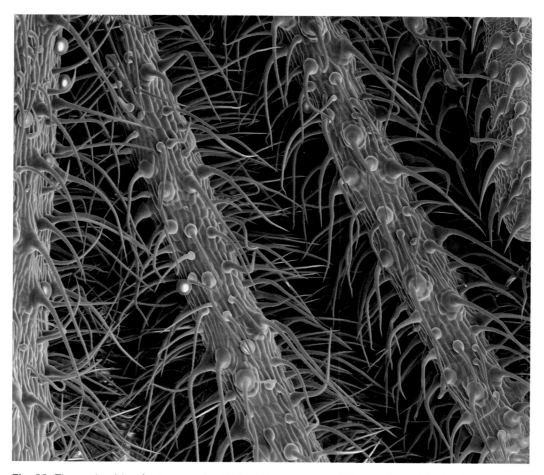

Fig. 39. The underside of a two-week-old plant shows a very different view of the leaf. Here it is protected by long, hair-like trichomes. Print magnification is x28.

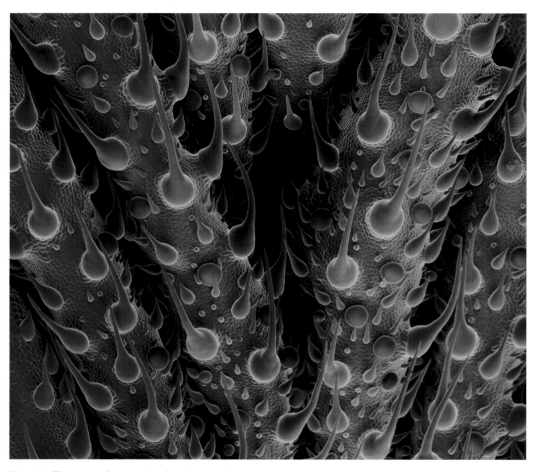

Fig. 40. The top of a new leaf collected from a two-week-old plant. The leaf is in the process of unfolding.

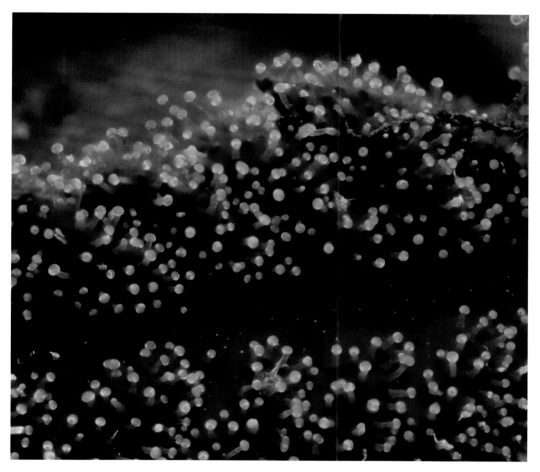

Fig. 41. Trichomes are photographed in ultraviolet light, which causes the cannabinoid compounds to fluoresce light blue. The chlorophyll that makes up the majority of the leaf glows red. This type of photography is an excellent way to show how closely the trichomes are packed together on the leaves in a mature bud.

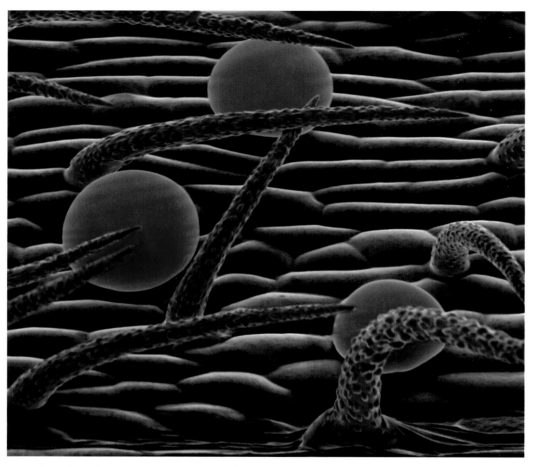

Fig. 42. An SEM image shows two types of the glandular trichomes common to the top of a leaf: glandular trichomes and the thorn-like trichomes. Print magnification is x340.

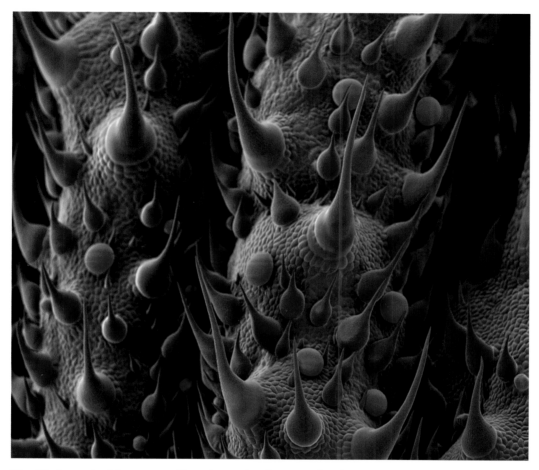

Fig. 43. A new leaf from a seedling shows the diverse collection of defensive structures the leaf sets up to protect itself from insect attack.

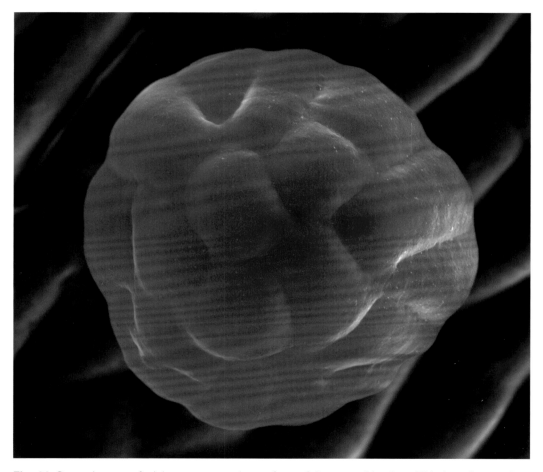

Fig. 44. Several types of trichomes cover the surface of the cannabis plant. This is a short variety that grows very close to the surface. This trichome top is made from about two dozen cells. All of these cells produce cannabinoids that protect against insect attack. Print magnification is x900.

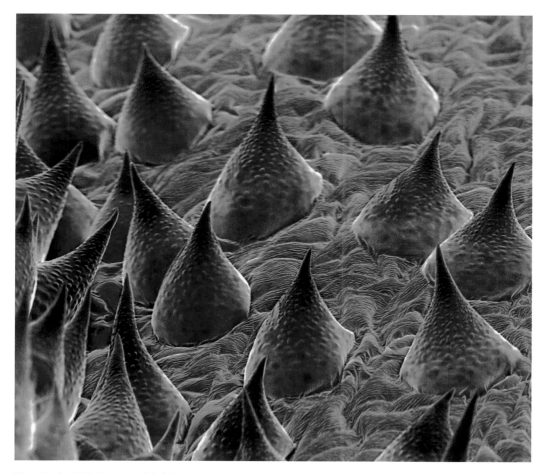

Fig. 45. An SEM image with false color showing the valley on the top of a leaf. The valley represents a nice place for an insect to snuggle and is also close to a leaf vein, so there is an abundance of protective structures here. Print magnification is x280.

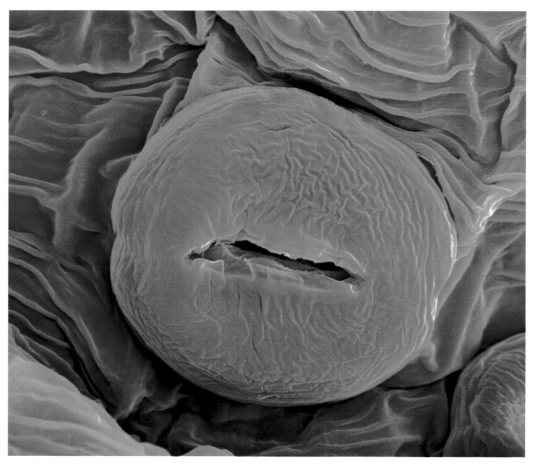

Fig. 46. This is a fairly high magnification SEM image of the stoma, the cell structure that allows the carbon dioxide to enter the leaf. It is made of two guard cells that open and close the vent depending on the time of day. These structures can be seen in numerous images. **Print magnification is x500.**

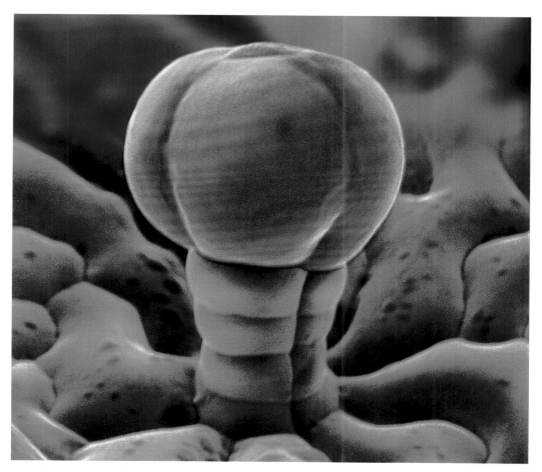

Fig. 47. A multi-cellular glandular trichome. This type of trichome is also responsible for manufacturing the cannabinoids. This low variety seems to be most common on leaves, although it can be found just about anywhere on the plant. It is relatively rare compared to the other varieties. Print magnification is x600.

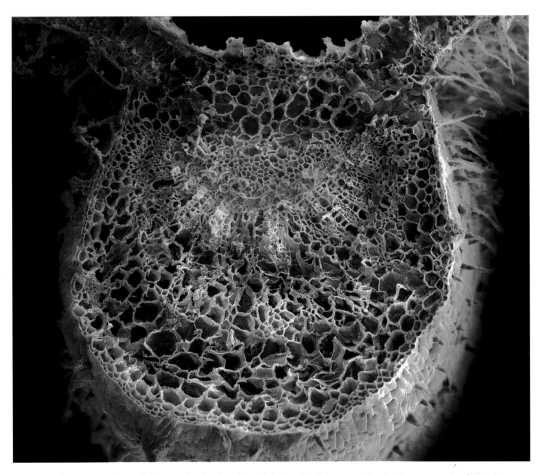

Fig. 48. Cross section of the major leaf vein, with the leaf bottom in the lower part of the image. The vein provides support and acts as the nutrient pipes.

Fig. 49. A light microscope image of a stained cross section of the leaf-supporting structure called the petiole. The curved section of the slice always points up on the plant. Microscope stains were added to increase the contrast. The petiole is 3 mm wide.

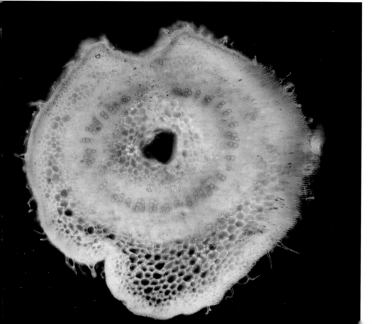

Fig. 50. A light microscope image of an unstained cross section of the petiole shows the distribution of green chlorophyll.

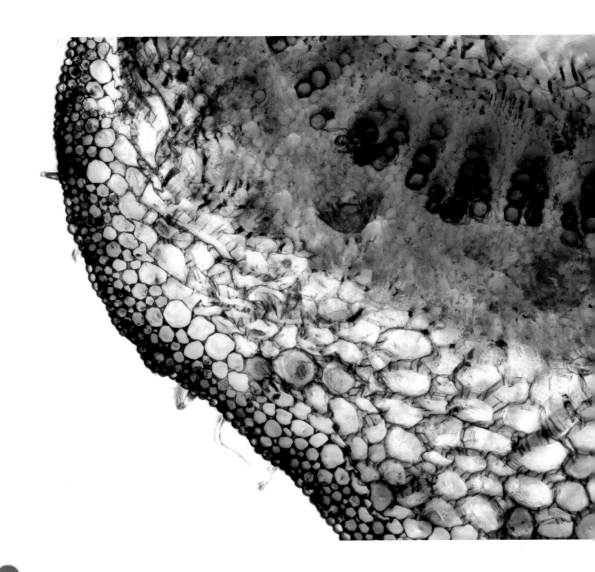

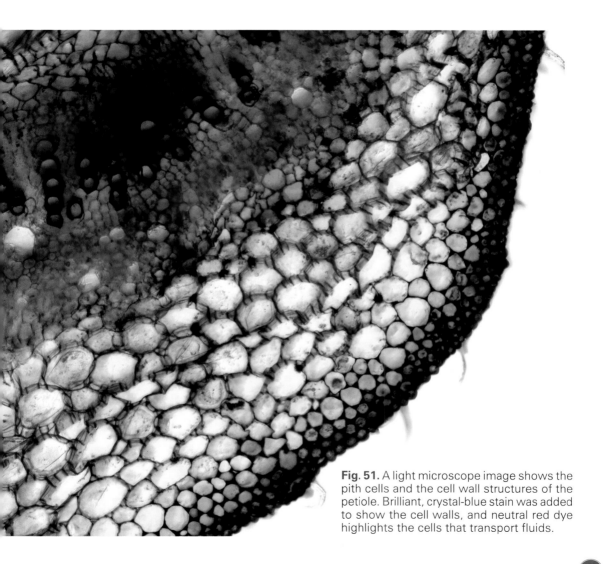

Fig. 51. A light microscope image shows the pith cells and the cell wall structures of the petiole. Brilliant, crystal-blue stain was added to show the cell walls, and neutral red dye highlights the cells that transport fluids.

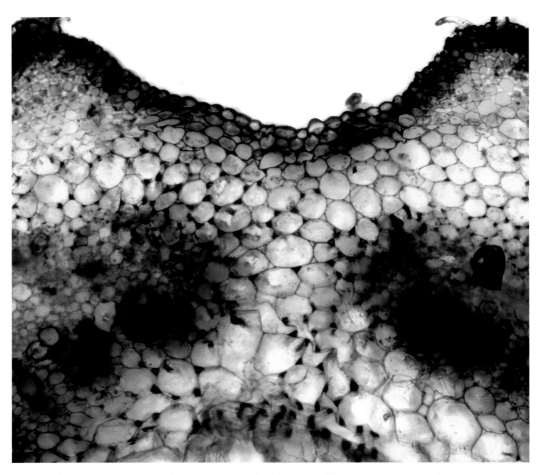

Fig. 52. A section of the petiole. Look for similarities and differences between this structure and the cross section of the stem. The little indent at the top acts like a gutter to channel water to the stem, where it can run down to the roots. The gutter is always at the top of the petiole. This is a common feature on many plants. The next time you have a close look at a plant, see if you can find it. Print magnification is x110.

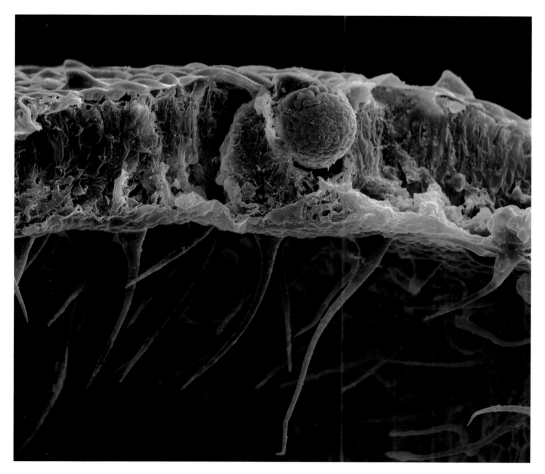

Fig. 53. The edge of a leaf shows a calcium oxalate crystal. These crystals are found throughout the plant and irritate the throat when the plant is smoked. Plants that have too many oxalate crystals are good candidates for modern THC extraction techniques. Calcium oxalate crystals in plants are called raphides. Humans have similar calcium crystals that can appear as kidney stones. These crystals help remove calcium build-up in the tissues and repel animals. Magnification is x120 on the printed page.

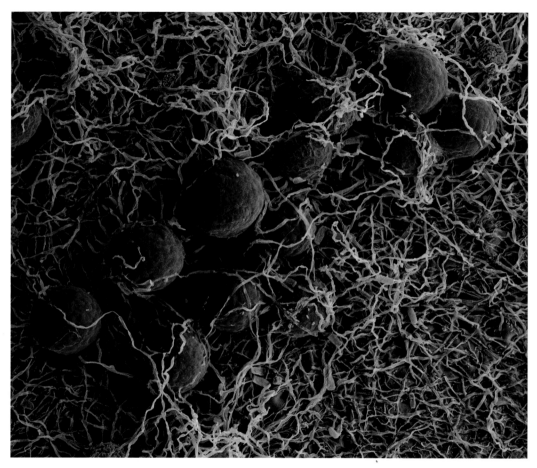

Fig. 54. False color SEM of parasitic powdery mildew, *Erysiphe* sp. This is a fairly common problem in hot, dry weather. Once the fungus is established, it is almost impossible to control. Tangled filaments growing across the leaf surface form the fungal colony and manifest as white spores. This mold also parasitizes the leaves of many other plants. Print magnification is x470.

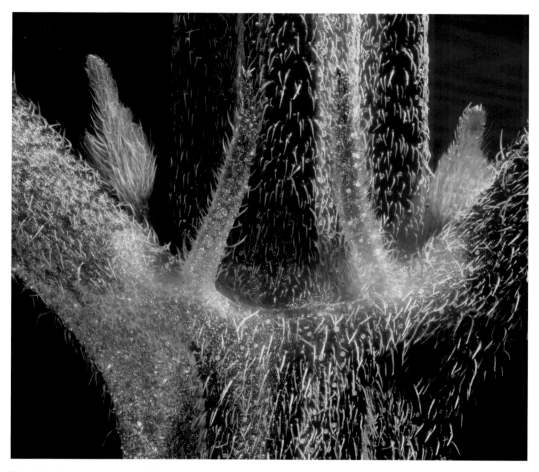

Fig. 55. A macro photo of the stem showing the node and petioles branching to each side. The two stubby leaf-like structures in the front are stipules. This plant was too young to determine its sex, but a week later it could be clearly identified as male. When sexing plants, give them time to develop so there is no guesswork.

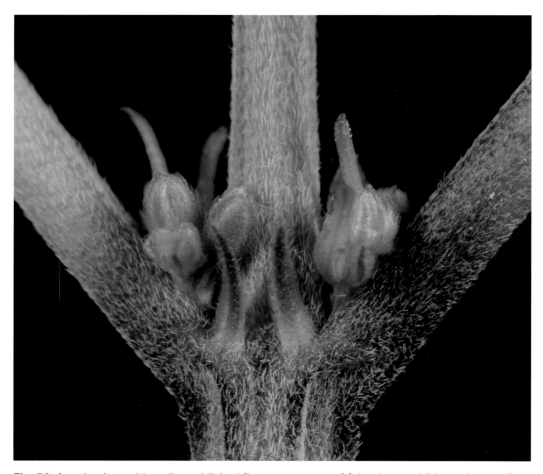

Fig. 56. A male plant with well-established flower structures. Male plants, which produce pollen, must be identified and removed as soon as possible to prevent them from pollinating the female plants. Unpollinated females produce copious amounts of THC and other cannabinoid compounds.

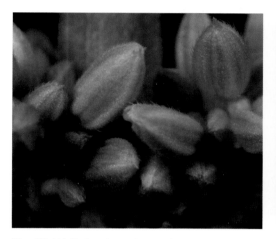

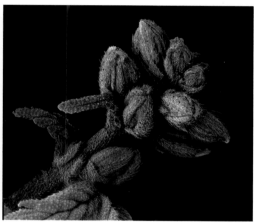

Fig. 57. Well-developed male flower buds a few days before opening.

Fig. 58. An SEM image of male flower clusters.

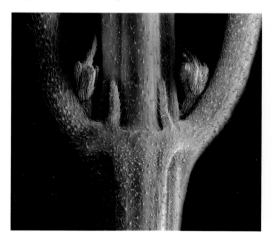

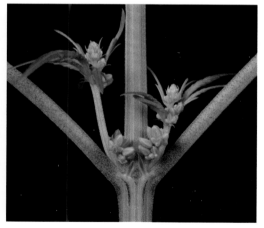

Fig. 59. An SEM image of the earliest stage of a male flower development, though clear sex identification is still a few days away.

Fig. 60. A well-developed cluster of male flowers a week away from producing pollen.

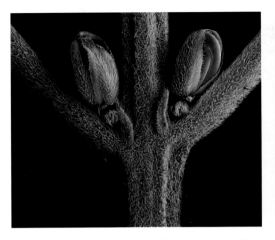

Fig. 61. Two male flowers about to open. In a few hours, this plant will be producing millions of pollen grains.

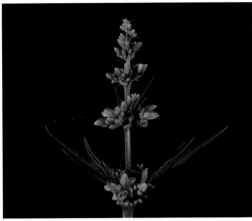

Fig. 62. A well-developed male flower. The flowers are placed so that the pollen can be dispersed by wind.

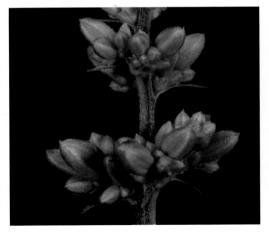

Fig. 63. Male pollen-producing flowers emerge at the top of the plant, allowing the wind to scatter the pollen.

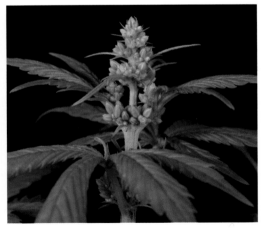

Fig. 64. The top of the male flower bud, ready to open and release its pollen.

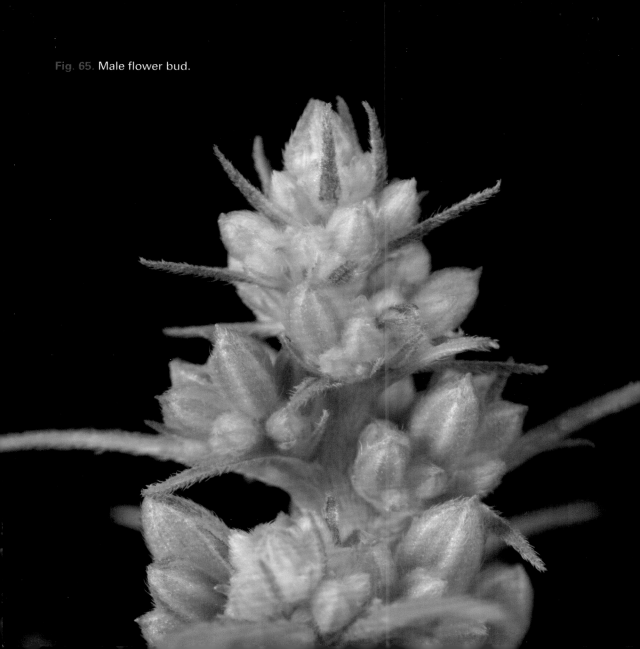

Fig. 65. Male flower bud.

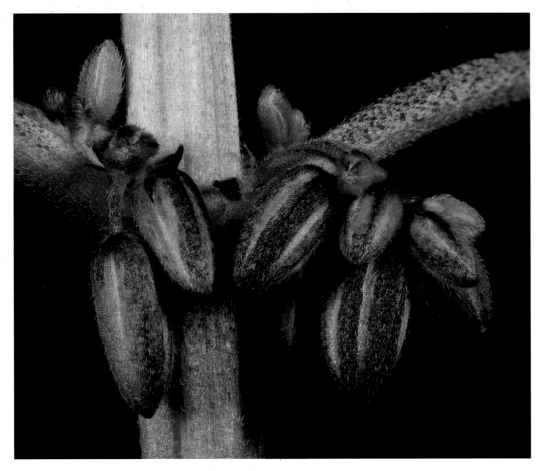

Fig. 66. A macro image of a cluster of male flowers about to open. This cultivar has red highlights on the stem and flowers.

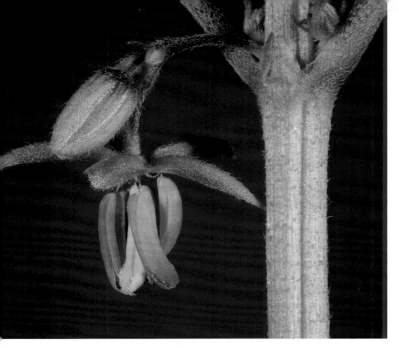

Fig. 67. The male flower is shown fully open and releasing pollen. The particles are small compared to many plants. Unlike plants that have brightly colored flowers to attract insects, the flower is a dull color because pollen is dispersed by the wind. Each plant can produce many millions of pollen grains.

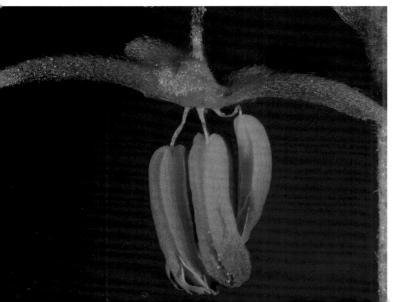

Fig. 68. The male flower in its full glory producing millions of pollen grains. The parts that look like a flower petal are the sepal, while the banana-shaped structures are the anther. The anther is held in place by the filament.

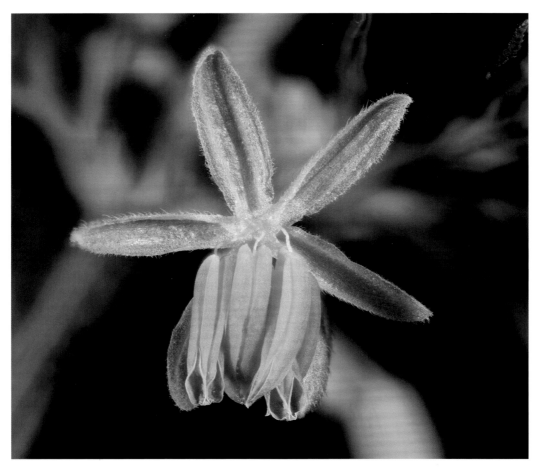

Fig. 69. A male flower fully open, setting pollen adrift on the air currents. One male plant can produce enough pollen to ruin a large crop of female plants, since female plants decrease THC production after they have been pollinated. The pollinated plant shifts energy to producing seeds.

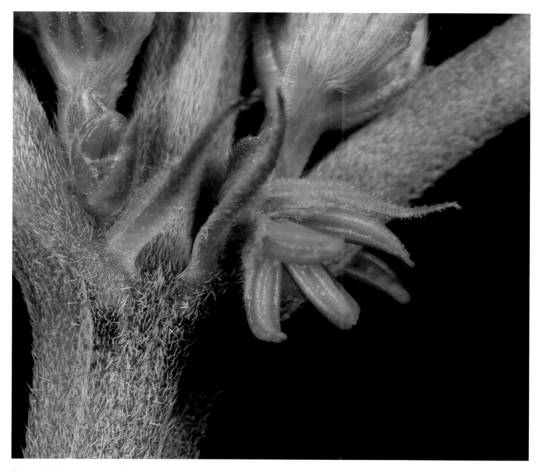

Fig. 70. This is one of the strange sights that is now quite common with cultivars. There is both a male and female flower on the same plant. The male flower has produced anthers for pollen production and is next to the female beaked bract showing the sticky extended stigmas. This plant, which produces both male and female parts, is called a hermaphrodite.

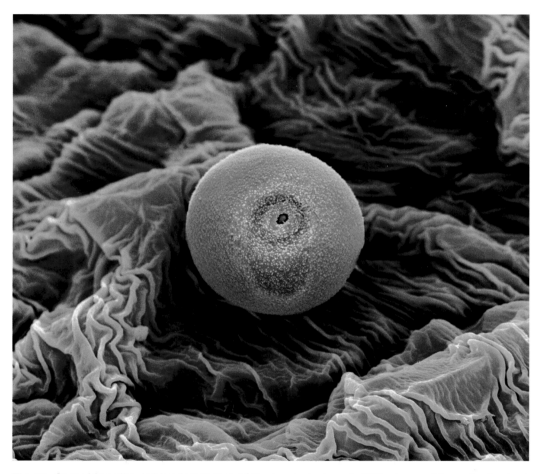

Fig. 71. Cannabis pollen is identical to that of the hops plant, and at 20 microns it is perfectly sized to be picked up by the slightest breeze. Since the plant does not depend on insects for pollination, it needs to make massive amounts of pollen grains to even have a remote chance of making seeds. Pollen is very fragile and the male plant had to be grown to flower to capture this image.

Fig. 72. A solitary male pollen grain. What genetic potential does it hold? Five pollen grains placed side by side would equal the diameter of a human hair. Designed to be efficiently scattered in the wind, a single pollen grain can travel a tremendous distance.

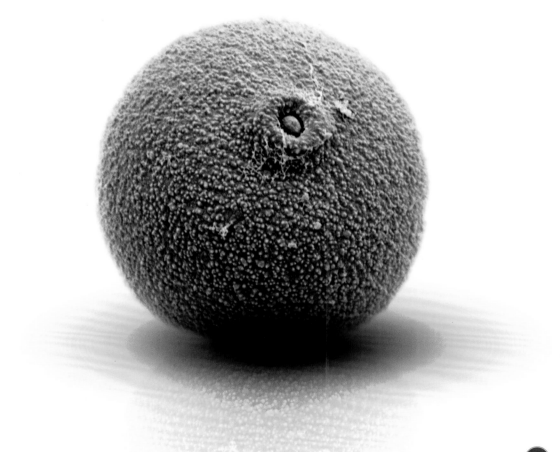

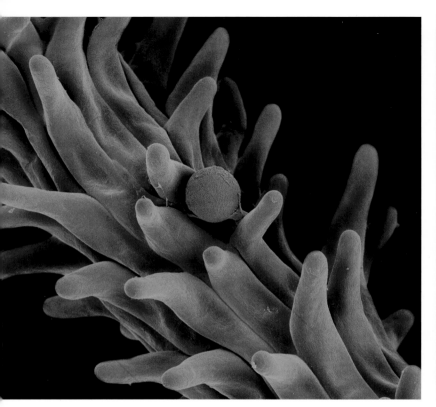
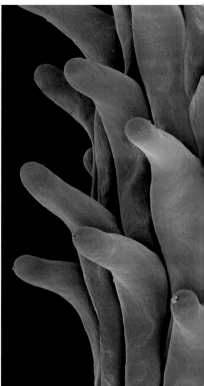

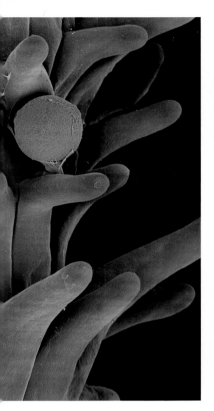
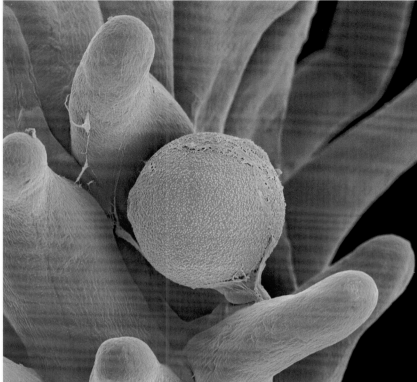

Left to right:

Fig. 73. A one-in-a-million event has taken place and the pollen grain has found the correct resting place on the female flower stigma. The pollen grain will contribute genetic material to the female flower to make a viable seed.

Fig. 74. The pollen is nestled into the female stigma to create a seed. To get this difficult shot, female and male plants were grown next to each other. After a few days, the female buds were collected and prepared for the SEM. One of the samples caught the pollen at exactly the right time. The pollen is too small to see with the human eye.

Fig. 75. The birth of a new cannabis seed captured for the first time. The life cycle will continue.

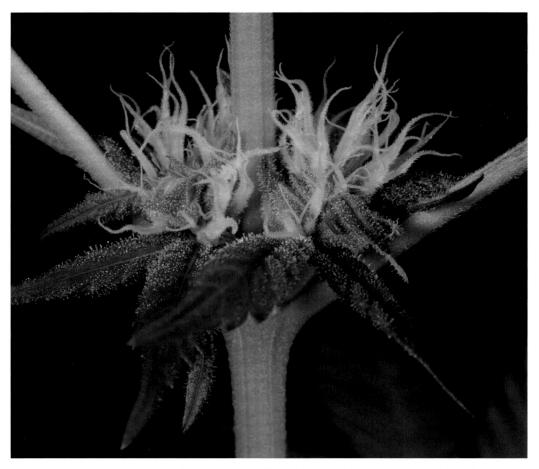

Fig. 76. Well-developed female flowers can easily be identified by their white, sticky stigma. This flower structure will continue to grow in size and produce more cannabinoids as long as it is not pollinated by a male plant.

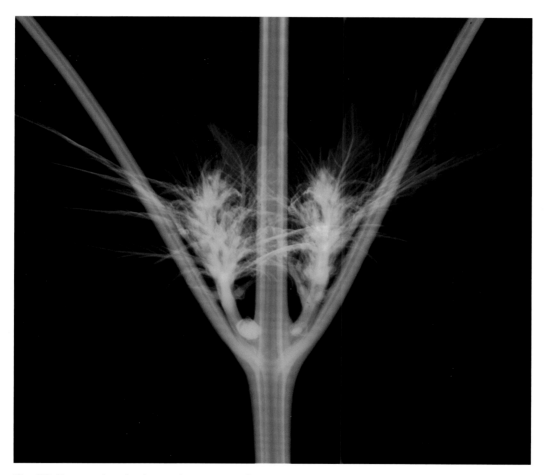

Fig. 77. To examine the internal structure of the two buds on each side of the stem, the plant is x-rayed. The hollow central cavity in the pith cells in the stem is clearly visible, as is the nesting pattern of the female flower bracts inside the bud.

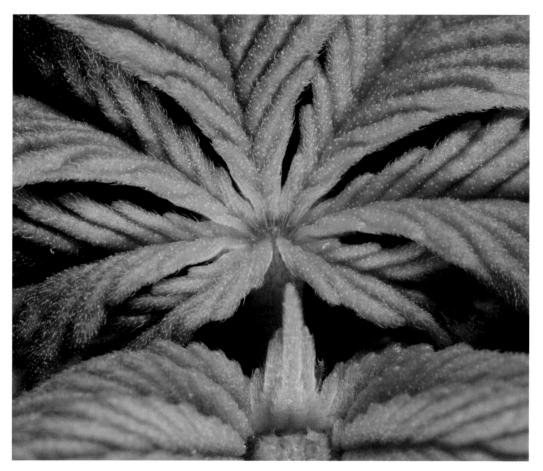

Fig. 78. A close-up image of the cannabis leaf. Can you see any trichomes scattered on the leaf?

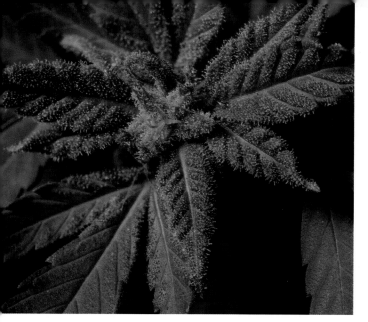

Fig. 79. A mature bud develops on a small plant late in the season. This plant was identified as having a number of double-headed trichomes. The plant expends a significant amount of energy to manufacture a bud covered in THC-laden trichomes.

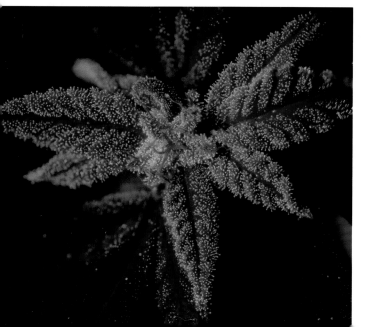

Fig. 80. A mature bud photographed in ultraviolet light, which causes the plant to fluorescence. The chlorophyll fluoresces bright red, while the THC-laden trichomes fluoresces light blue. The colors in a UV image of a bud greatly depend on the light source, filters used, and sensitivity of the camera sensor.

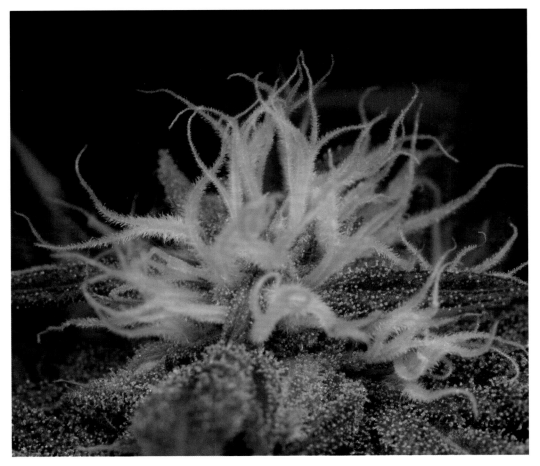

Fig. 81. The mature female flower in all its glory. The stigmas are the showy filaments that reach out looking for pollen. This bud will be ready for harvest in another month.

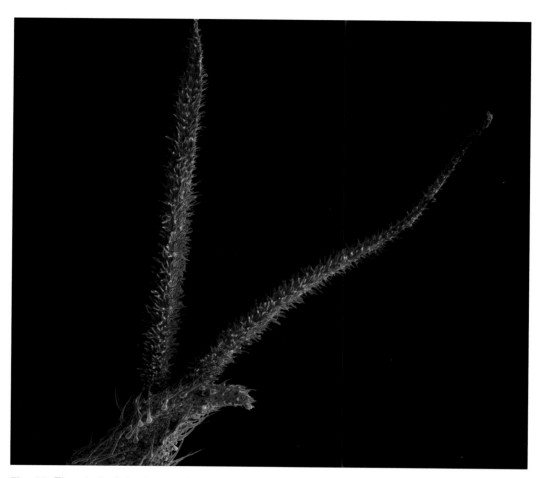

Fig. 82. The pistil of the female flower branches into two stalks called stigma. These structures are sticky to catch pollen and extend down into the beak-shaped bract. When the flower is pollinated, the base structure will develop into a seed. Print magnification is x20.

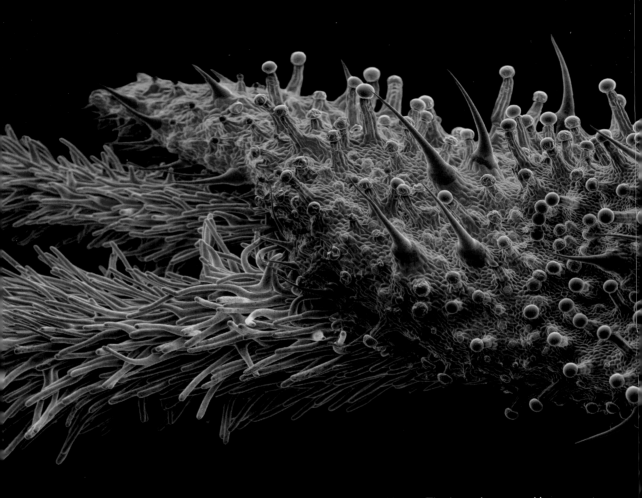

Fig. 83. An SEM image of the stigma and the beak-shaped bract. The bract is covered in a carpet of different types of low trichomes. The bract is the source of many of the following images and contains the highest diversity of glandular trichome types on the plant. As long as the plant is not pollinated, the trichomes in this area will continue to get larger and produce more cannabinoid chemicals. The role of the glandular trichomes in this area is to protect the flower and resulting seed from insect attack.

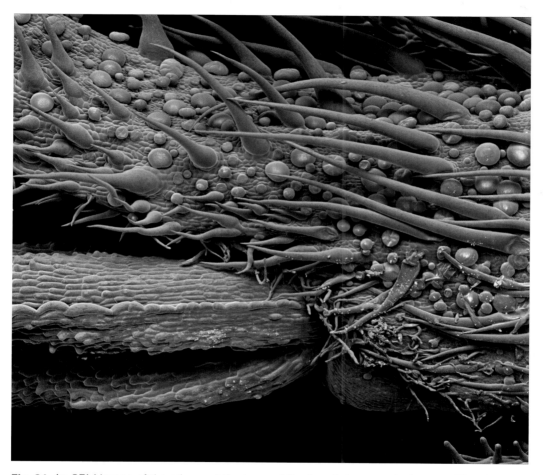

Fig. 84. An SEM image of the stigma at the top and the female bract at the bottom. The glandular trichomes are clearly visible. A number of the trichomes tops are made from multiple cells. Print magnification is x80.

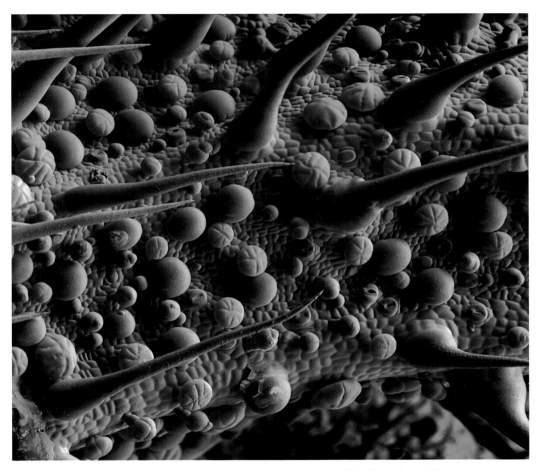

Fig. 85. An SEM image of the female flower bract covered with glandular trichomes. Print magnification is x180.

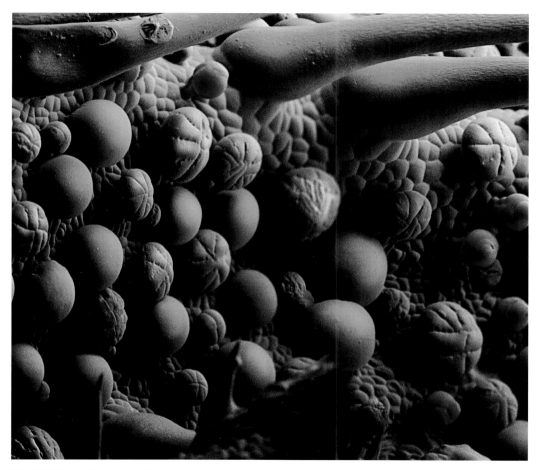

Fig. 86. This higher magnification image shows the amazing variety of THC-containing cells covering this part of the plant. Print magnification is x540.

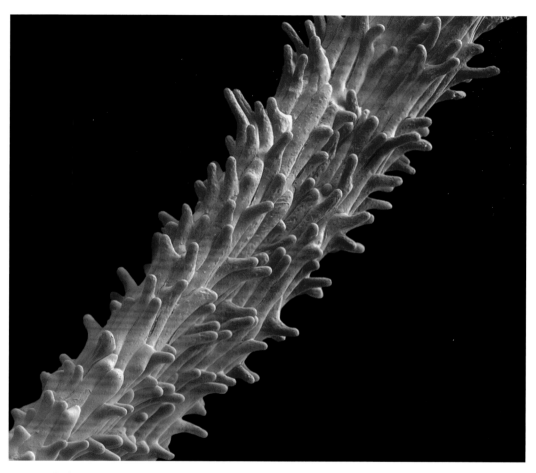

Fig. 87. A single stigma, whose sticky structure collects male pollen. Print magnification is x140.

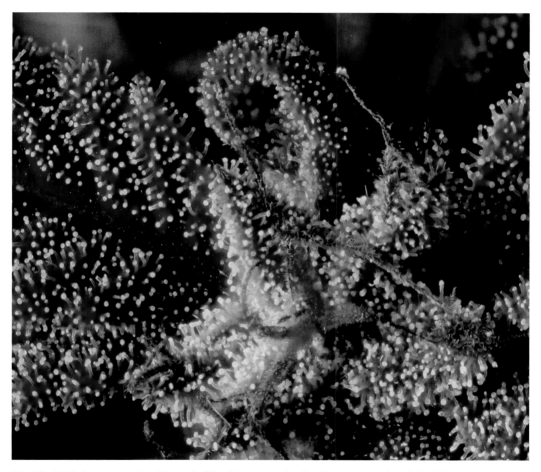

Fig. 88. UV light causes the chlorophyll in this mature bud to fluoresce red and the high concentration of cannabinoids to glow blue.

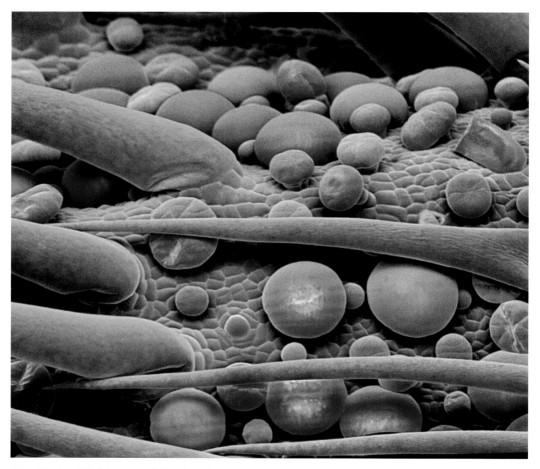

Fig. 89. An SEM image of the female flower bract showing the amazing variety of the plant's defensive glandular trichomes. Print magnification is x560.

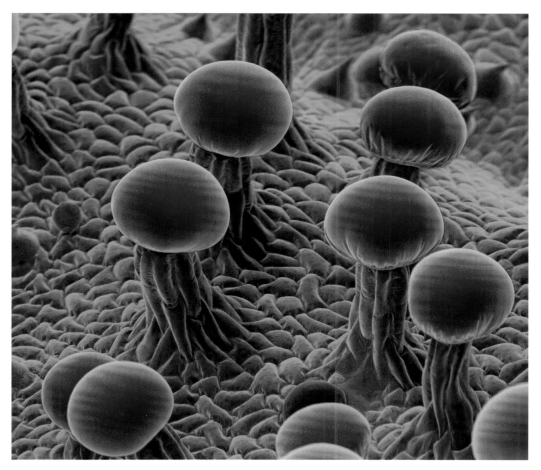

Fig. 90. An SEM image of the top of a cola blade (the solitary leaf that extends out from a large bud). The average size of the head of the glandular trichome is 60 microns. The glandular trichomes are responsible for the smell of a plant when you brush it. These spherical cells break open and the chemicals that have a low vapor pressure quickly vaporize. Plants such as basil, rosemary, tobacco, mint, lavender, and cannabis share similar structures. The technical term for this structure is a stalked glandular trichome.

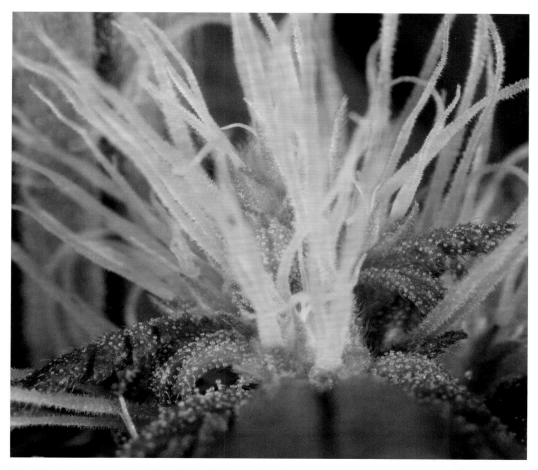

Fig. 91. A close-up of the female bud shows the sticky stigma filaments and the bract leaves at the base of the bud covered with copious amounts of stalked glandular trichomes.

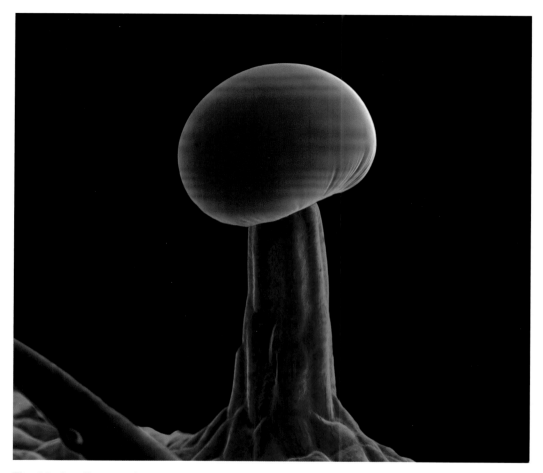

Fig. 92. A solitary capitate stalked glandular trichome collected from the top surface of a leaf extending out of a bud. The head of the trichome is 60 microns in diameter. The chemical THC wards off insect and herbivore predators. It just so happens that humans find this chemical of medical interest and have crossbred the plant to increase the THC levels. THC is shorthand for tetrahydrocannabinol, the psychoactive chemical in the cannabis plant. Another well-known psychoactive chemical is caffeine. Print magnification is x1165.

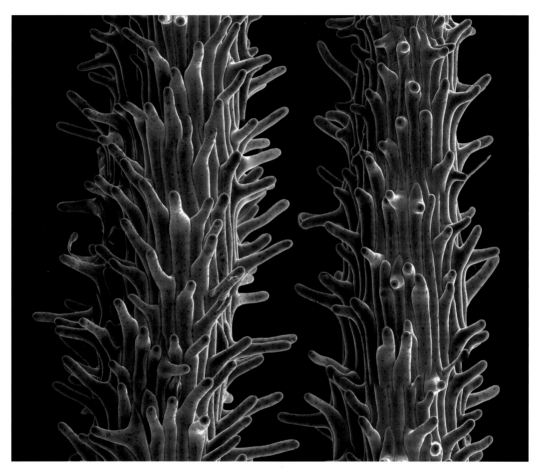

Fig. 93. Each of the stigma shown here is 1 mm in diameter.

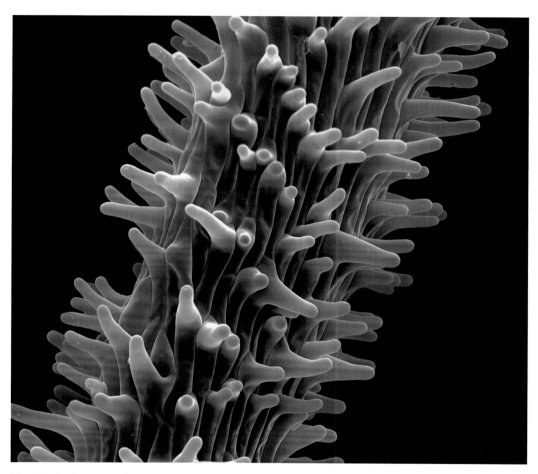

Fig. 94. A close-up of the stigma extending from the female flower. These sticky structures can extend up to 14 mm from the bud. The plant uses this structure to capture one or more pollen grains for transfer of genetic material, a process critical for the creation of a seed.

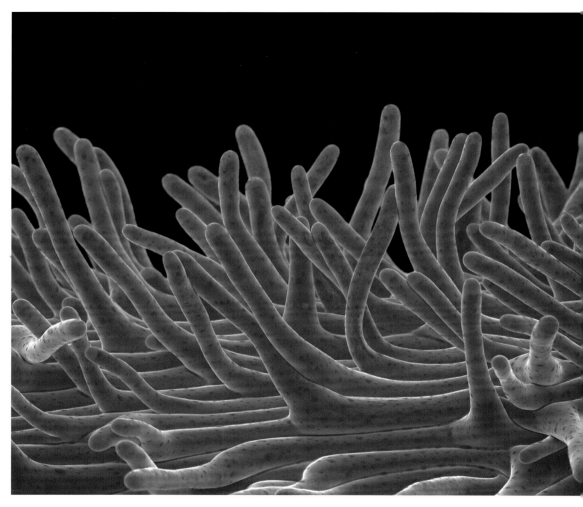

Fig. 95. A false color SEM image of the surface of the female flower stigma. The plant uses this structure to capture pollen grains.

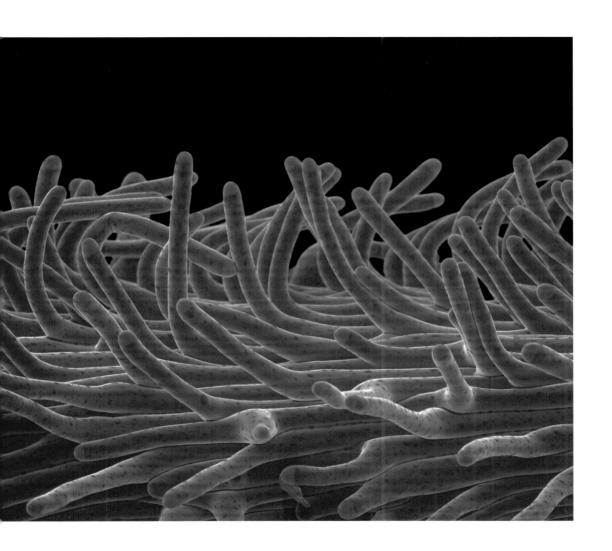

Fig. 96. The edge of a leaf collected from a mature bud shows trichomes. The image was taken with ultraviolet light, which causes the normally green chlorophyll to fluoresce red and the THC to fluoresce yellow-green. Images like this are a unique way to evaluate the concentrations of cannabinoids in the trichomes on the leaves.

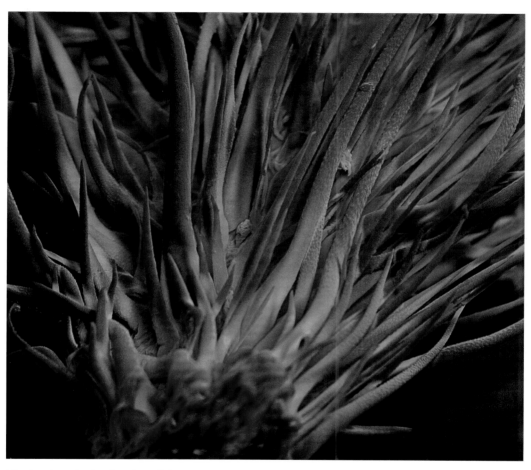

Fig. 97. A typical collection of the needle-like trichomes found at the bottom of the female beaked bract, virtually impenetrable to microscopic insects.

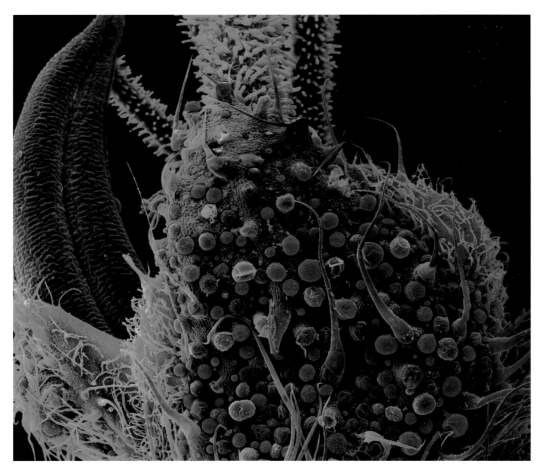

Fig. 98. Color has been applied to this SEM image of the bud. The female beak-shaped bract is in the center, while the stigma points toward the top. The banana-shaped structure on the left is actually a male flower part, anther, that will produce pollen. It is not uncommon for female plants to produce these male structures for self-pollination. Print magnification is x120.

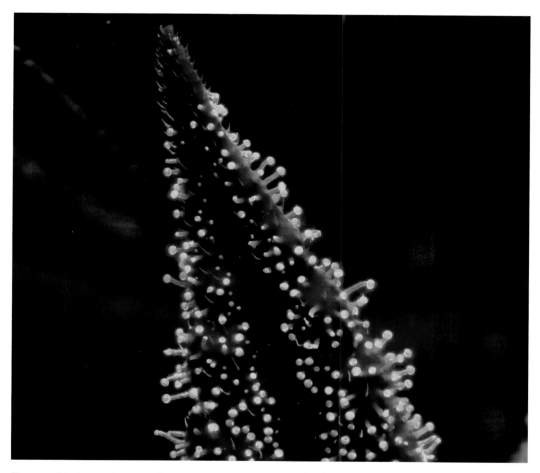

Fig. 99. Photographed in ultraviolet light at 2x magnification, the leaf shows mature trichomes filled with cannabinoids

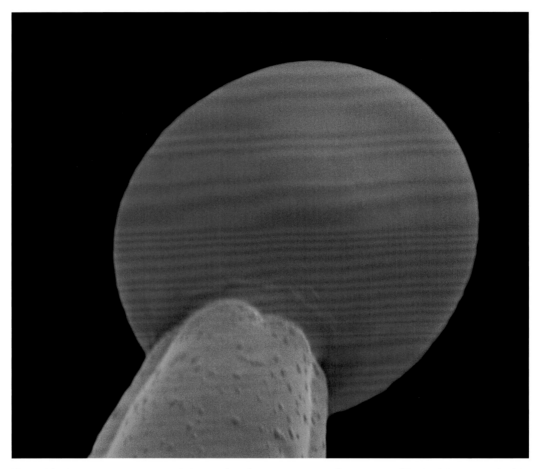

Fig. 100. A stalked glandular trichome looking up at the cell structure filled with cannabinoids compounds. Researchers are still trying to determine if the cannabinoids are produced here or just stored at this location. These glandular trichomes range in size from 60 to 90 microns in diameter. Print magnification is x2050.

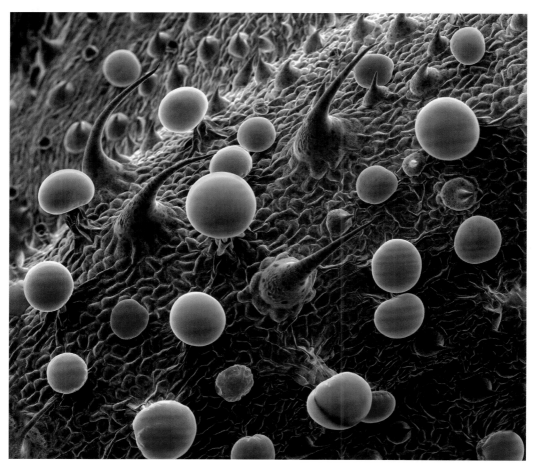

Fig. 101. The edge of a bract leaf extending from a female bud. This surface has at least four types of trichomes.

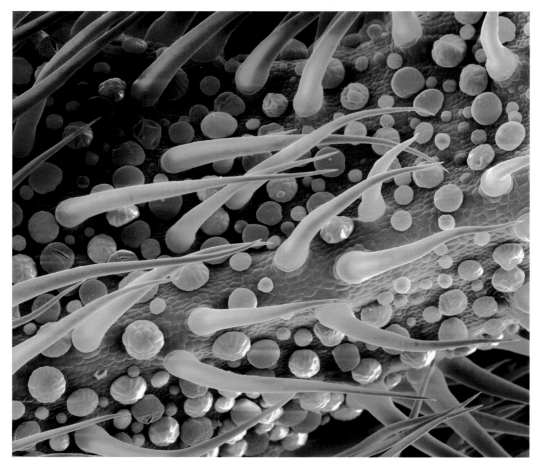

Fig. 102. The edge of a female bract shows numerous low surface glandular trichomes.

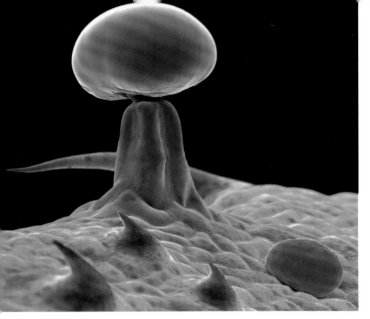

Fig. 103. A nice collection of four types of trichomes found on the edge of a bract leaf: the tall stalked glandular trichome, the low surface glandular trichome, the tall thorn, and the low thorn. These trichomes use their chemical and physical superpowers to protect the plant from insects and grazing animals. Print magnification is x600.

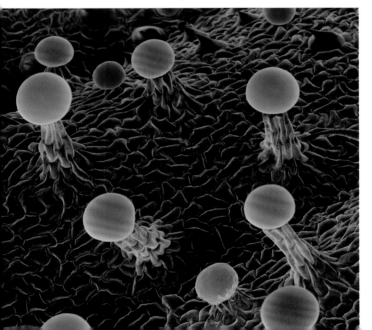

Fig. 104. The surface of a bract showing the characteristic stalked glandular trichomes. Print magnification is x150.

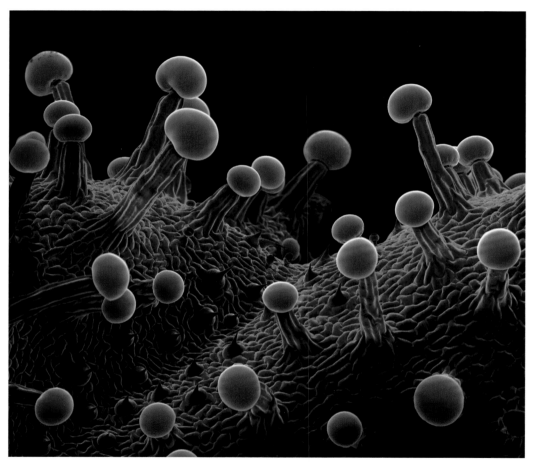

Fig. 105. Trichomes in the fold of a young bract leaf. The older the leaf, the higher the chances the trichomes have stuck together or collected dust. This plant was grown in an isolated hydroponic system for the sole purpose of being the subject of the scanning electron microscope. Print magnification is x200.

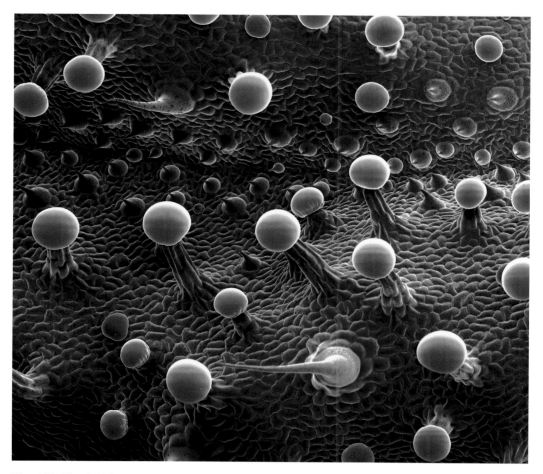

Fig. 106. The fold in a bract leaf. How many different kinds of trichomes can you find? Print magnification is x170.

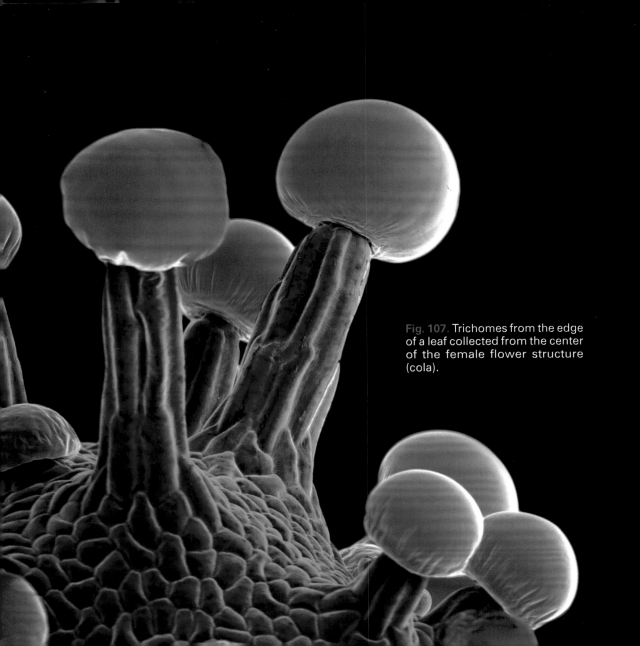

Fig. 107. Trichomes from the edge of a leaf collected from the center of the female flower structure (cola).

Fig. 108. The edge of a leaf photographed in an ultraviolet fluorescent microscope. The edge of a cannabis leaf is illuminated with ultraviolet light and photographed through special filters that only allow the fluorescent colors from the plant cells to pass through. The THC and other cannabinoids fluoresce bright green while the chlorophyll in the leaf emits red light. Special microscopes like this allow quick analysis of the THC distribution in the cannabis plant.

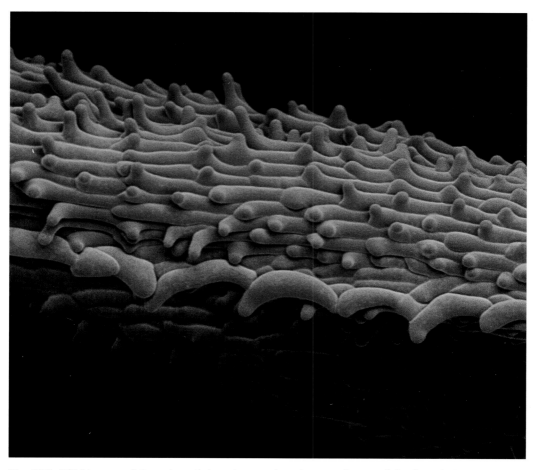

Fig. 109. SEM image of the edge of the stigma where it extends out of the female beaked bract. At this location, the stigma is 1.2 mm wide.

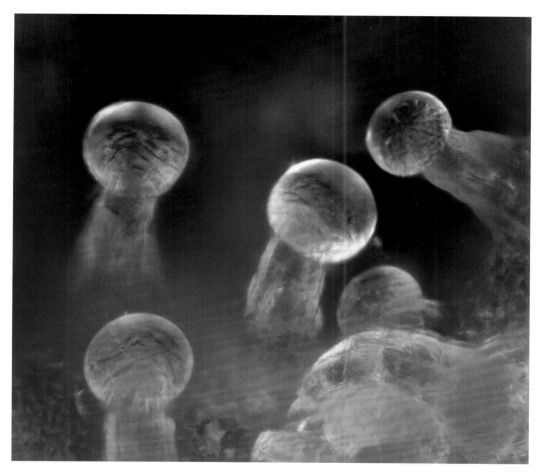

Fig. 110. This image shows the true colors of the cannabis trichomes on the edge of a leaf collected from a mature bud. Each of the trichomes is .15 mm across. The photo was taken with a reflected light microscope and made from twenty images taken at different points of focus.

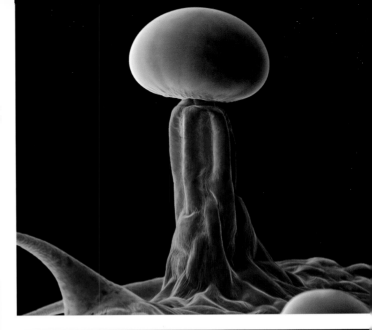

Fig. 111. Stalked glandular trichomes on a bract leaf collected from the base of a bud. Print magnification is x350.

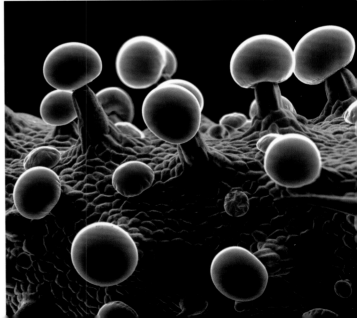

Fig. 112. Stalked glandular trichomes on a bract leaf collected from the base of a bud. Print magnification is x130.

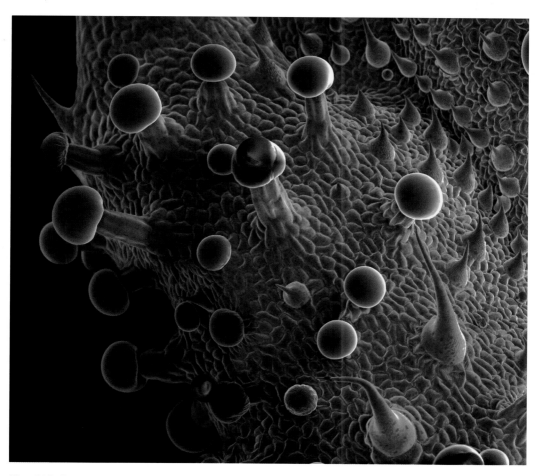

Fig. 113. Stalked glandular trichomes on a bract leaf collected from the base of a bud. Print magnification is x150.

Fig. 114. An insect-damaged portion of an adult cannabis leaf. The plant is fluorescent, and the chlorophyll in the leaf fluoresces red under ultraviolet light. The portions containing the cannabinoids fluoresce green under ultraviolet light. The plant produces more cannabinoids on the damaged areas. The circles of lighter green are top-down images of trichomes with high concentrations of cannabinoids.

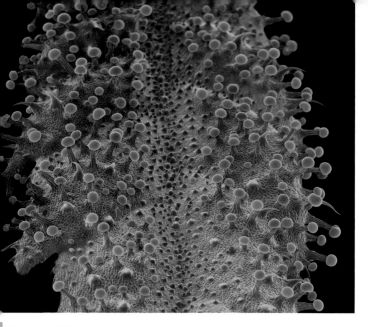

Fig. 115. A bract leaf collected from a mature bud. This is the concentration of trichomes that breeders hope to achieve on every cultivar. False color SEM at a print magnification of x18.

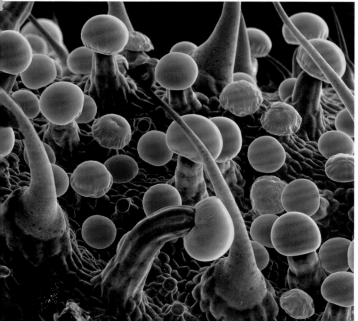

Fig. 116. The edge of a bract leaf collected from a large bud.

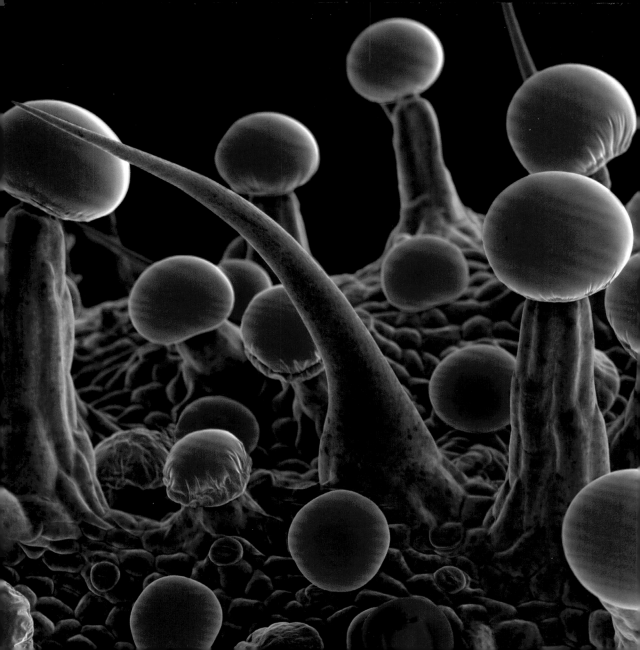

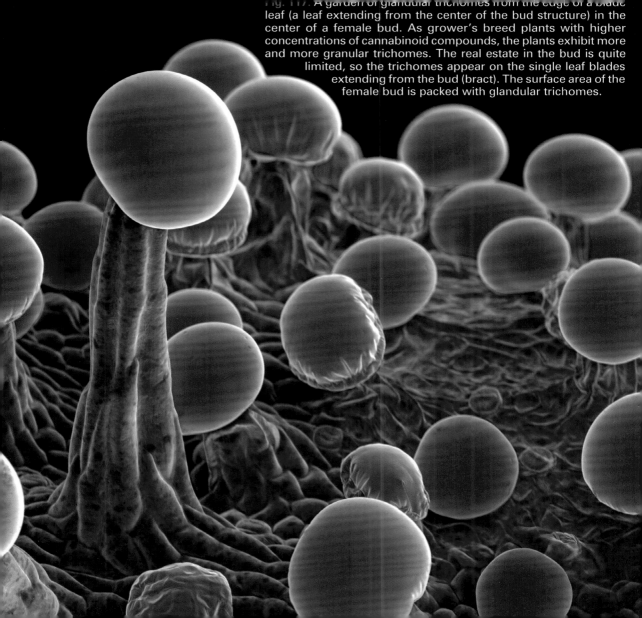

Fig. 117. A garden of glandular trichomes from the edge of a blade leaf (a leaf extending from the center of the bud structure) in the center of a female bud. As grower's breed plants with higher concentrations of cannabinoid compounds, the plants exhibit more and more granular trichomes. The real estate in the bud is quite limited, so the trichomes appear on the single leaf blades extending from the bud (bract). The surface area of the female bud is packed with glandular trichomes.

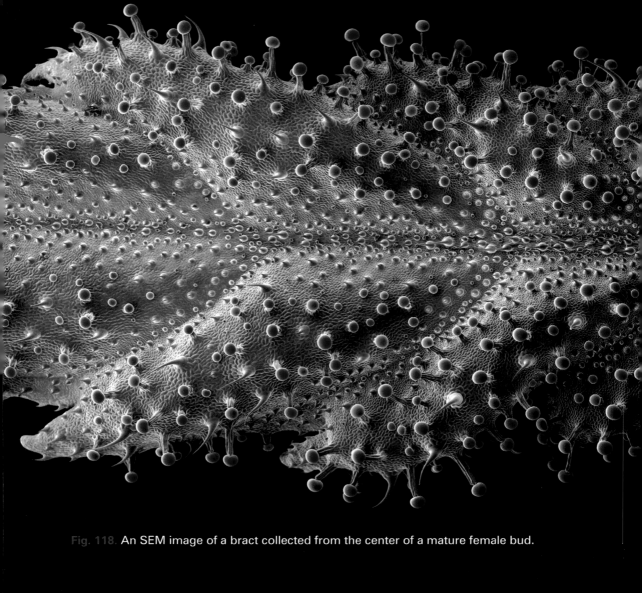

Fig. 118. An SEM image of a bract collected from the center of a mature female bud.

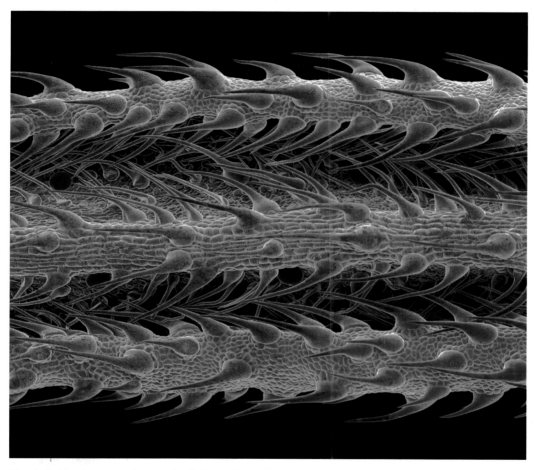

Fig. 119. The bottom of a new leaf shows lots of spiked trichomes to deter insects. At the top of this leaf are the abundant stalked glandular trichomes.

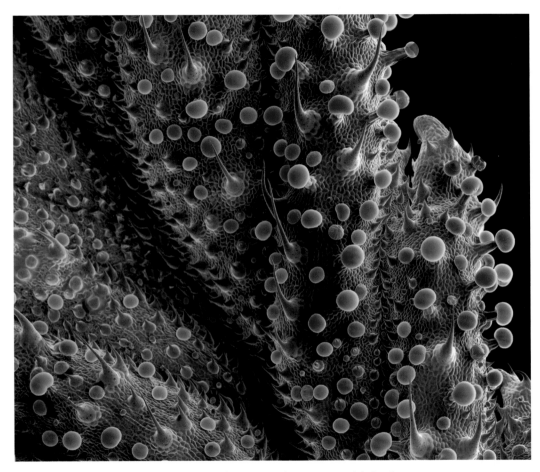

Fig. 120. The base of a young bract leaf collected from a cannabis bud.

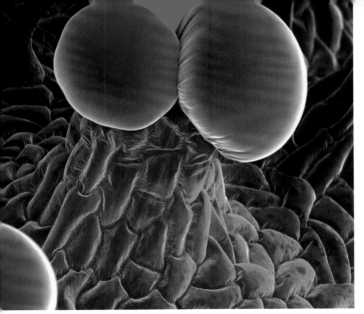

Fig. 121. A false color SEM of a double capped stalked glandular trichome. These types of trichomes are now fairly common, as the plants are bred to create cultivars with higher and higher levels of cannabinoids. Given the limited surface area of the bract leaf, one way to get higher levels of chemicals is for the plants to produce two glands on the top of a trichome. In the future, plants will likely have three or four glands on the top of the stalk. These double trichomes structures are hidden in several other images for the astute reader to find.

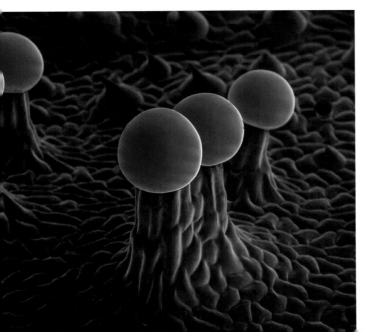

Fig. 122. A SEM image from a bract leaf collected from a bud. This image shows another two-headed, double-capped stalked glandular trichome.

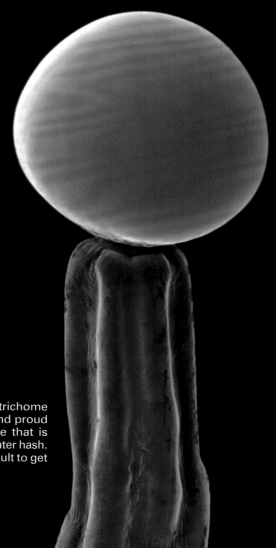

Fig. 123. A solitary stalked glandular trichome from a mature bud standing alone and proud above the leaf. This is the structure that is broken off in cold water to make ice water hash. Print magnification is x1000. It is difficult to get a clean image of a solitary trichome.

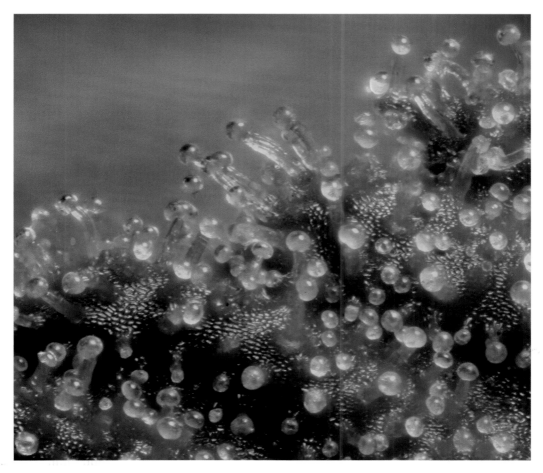

Fig. 124. The edge of a leaf inside a well-developed cannabis bud shows numerous trichromes laden with powerful cannabinoids. These trichomes emit an odor that can travel quite a distance. After photographing these samples, the microscopes will smell like fine bud particles for a few days.

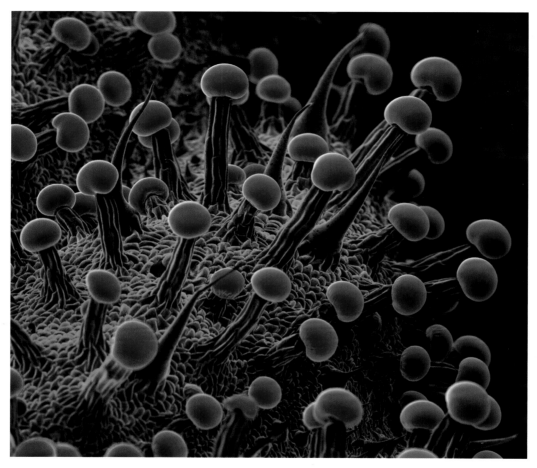

Fig. 125. The edge of a female bract leaf contains the most cannabinoids. It is often difficult to find a location where there are no trichomes stuck together.

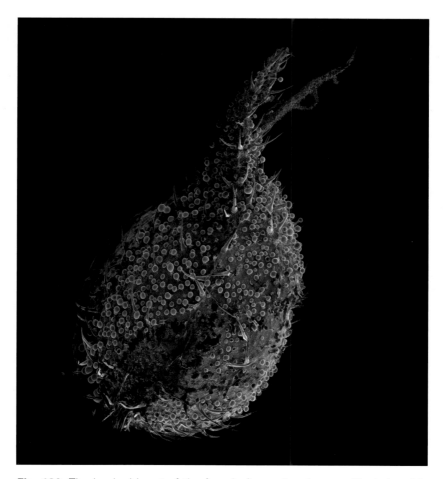

Fig. 126. The beaked bract of the female flower has been pollinated and is swollen with a seed. The seed will need to mature for a few weeks before it can be harvested and dried for eating, or stored for a future crop of cannabis.

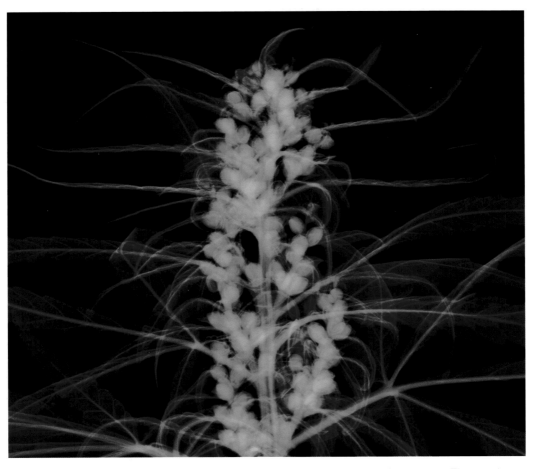

Fig. 127. An x-ray image of a bud showing well-developed seeds ready for harvest. The seeds are packed with nutrients and attract just about every mouse and bird.

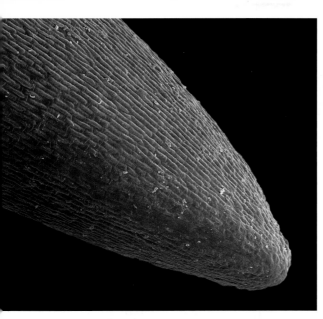

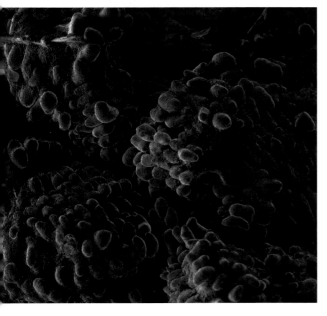

Left:

Fig. 128. An SEM image of the tip of a root extending from a newly germinated seed. The importance of the roots cannot be stressed enough. These structures collect nutrients and regulate water in the plant. The health of the root system is as important as the health of the leaves. Since the roots are not easily seen, they often are overlooked in the plant's care.

Fig. 129. A light microscope image of a root section taken two centimeters below the soil surface. This section was taken from a mature male plant and shows the difference between the root and the stem. Note the absence of pith cells and central cavity, the plant structure is quite different here.

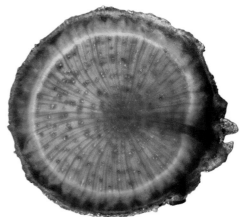

Fig. 130. A common knobby structure scattered all over the roots portends the development of a new root system. If the cells are correctly stimulated, a shoot will emerge. This is often called the location of an adventurous root. On some plants, these structures are visible above the soil surface.

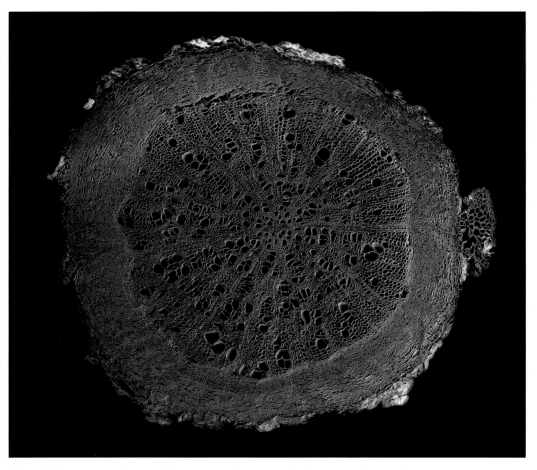

Fig. 131. A root sample was sliced perpendicular to the direction of growth.
This sample was collected 15 cm below the soil surface.

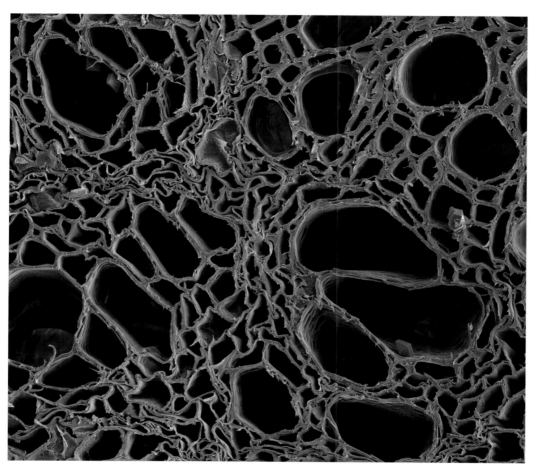

Fig. 132. Close-up of the root transport cells. Minute crystals are visible on close examination.

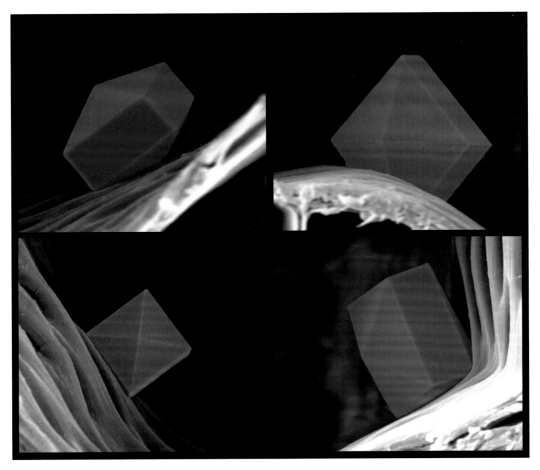

Fig. 133. There are numerous crystals in the roots of the plant. The exact composition of these are currently unknown and their role in the plant's life cycle is a mystery. Why are they there? What do they do? What is their chemical composition? These are a few of the questions that emerge when viewing cannabis with this level of magnification. Print magnification is 4300x.

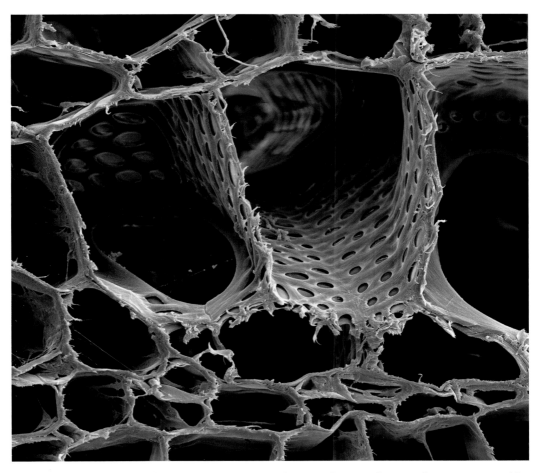

Fig. 134. The root is full of cells that transport nutrients and water. Some cells are supported by a screen-like mesh that allows liquids to flow to adjacent cells. Print magnification is x2100.

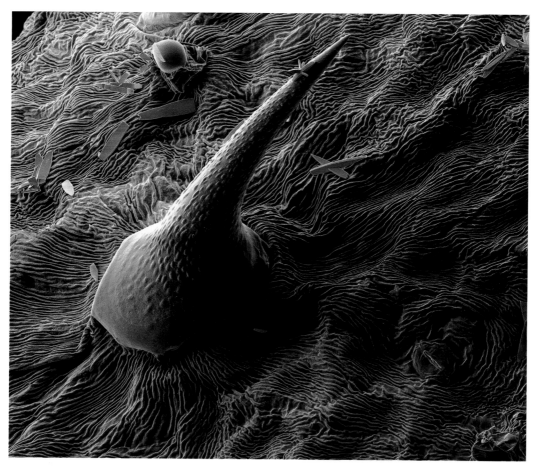

Fig. 135. Careful examination of this preserved low-quality cannabis, collected in 2012, shows that it is covered with small blue crystals of synthetic cannabis. Analysis was inconclusive on which designer drug it was. Synthetic cannabinoids now represent about twenty different compounds with mostly undocumented effects. These compounds are rarely found in today's samples, as legalization of cannabis has driven these synthetic products from the market.

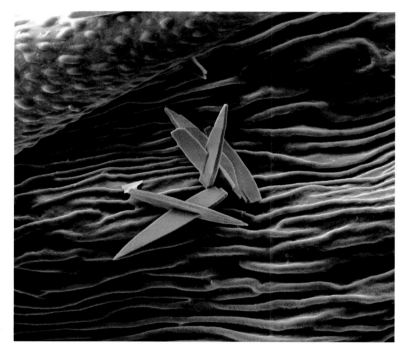

Fig. 136. A close-up of the previous image shows the synthetic cannabinoid chemical crystal. The addition of designer drugs to cannabis should disappear in the future if marijuana becomes legal on a federal level.

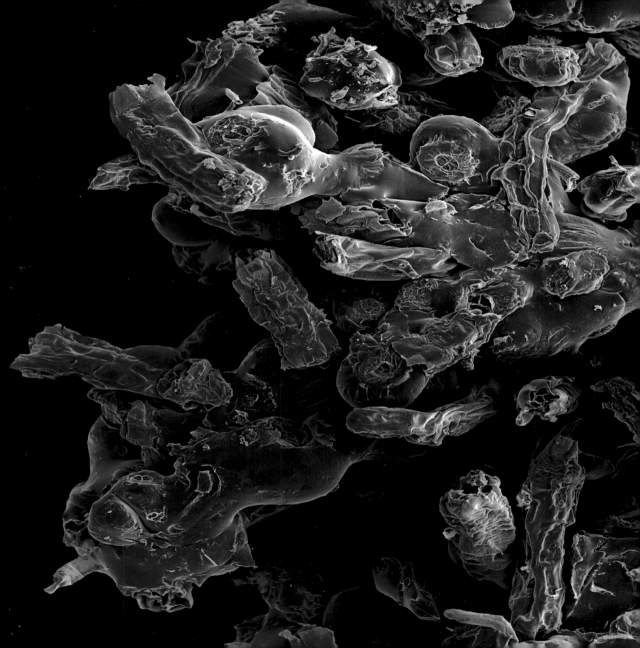

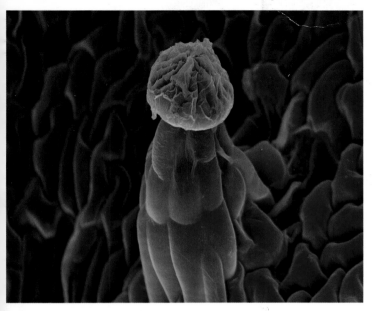

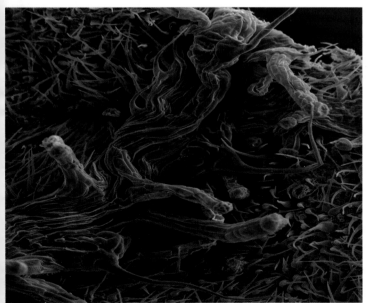

Opposite page:

Fig. 137. A sample of ice water hash shows one of the modern processes to create the highest concentration of cannabinoids per weight without the use of chemical extraction. It involves placing the mature female buds in ice water. The cold water makes the granular trichomes brittle. As the buds are agitated, the trichomes break off and sink in the cold water. The trichomes are dried and sorted by size with a screen. The resulting material is a wrecking yard of trichomes all stuck together. The extremely high concentration of cannabinoids in these glandular trichomes make the samples quite odiferous.

Top left:

Fig. 138. This cannabis sample was found in a typical medical dispensary. The cells are dried out and the glandular head of the stalked trichome has shrunk due to the loss of volatile compounds.

Left:

Fig. 139. The edge of a dried bract collected from a dried bud. This sort of sample is not very interesting from a plant science point of view, but is included here to show what an average cannabis sample looks like.

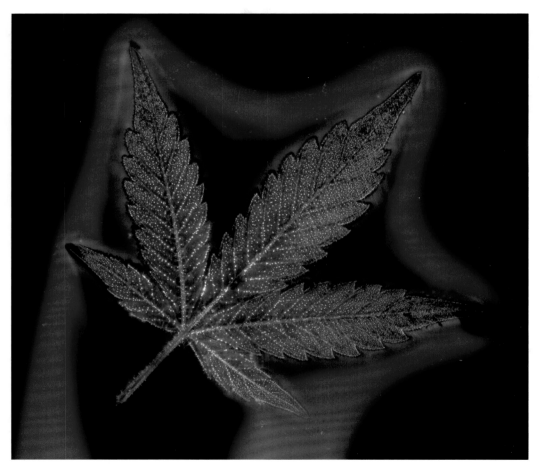

Fig. 140. The last image is a bit of fun. An immature cannabis leaf (only five blades) was photographed in an electrical discharge system to show high-voltage electrical corona discharge from the leaf. Some people believe that these types of images reveal the plant's mystical properties, but in reality they just make cool pictures.